MAR 0 7 2003

CAPITAL AREA DISTRICT LIBRARY

D1538121

IMAGES
of America

EAST LANSING

COLLEGEVILLE REVISITED

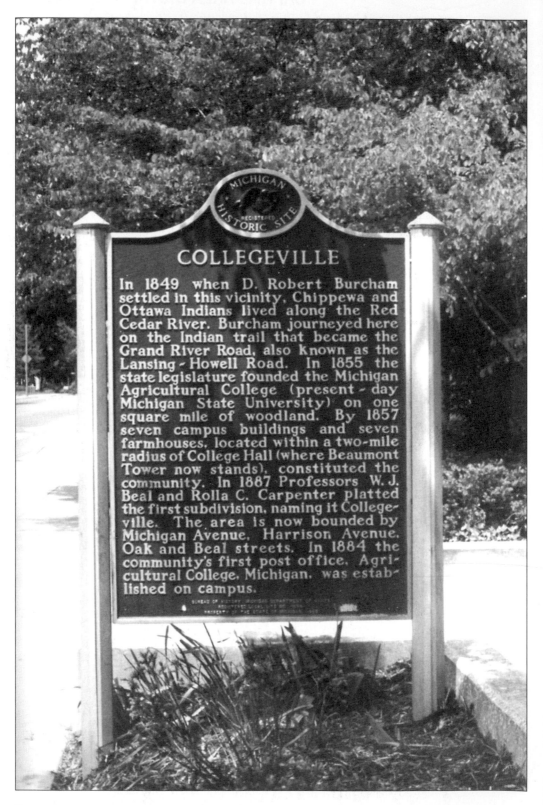

COLLEGEVILLE

In 1849 when D. Robert Burcham settled in this vicinity, Chippewa and Ottawa Indians lived along the Red Cedar River. Burcham journeyed here on the Indian trail that became the Grand River Road, also known as the Lansing - Howell Road. In 1855 the state legislature founded the Michigan Agricultural College (present - day Michigan State University) on one square mile of woodland. By 1857 seven campus buildings and seven farmhouses, located within a two-mile radius of College Hall (where Beaumont Tower now stands), constituted the community. In 1887 Professors W. J. Beal and Rolla C. Carpenter platted the first subdivision, naming it Collegeville. The area is now bounded by Michigan Avenue, Harrison Avenue, Oak and Beal streets. In 1884 the community's first post office, Agricultural College, Michigan, was established on campus.

IMAGES
of *America*

EAST LANSING

COLLEGEVILLE REVISITED

Whitney Miller

ARCADIA

Copyright © 2002 by Whitney Miller.
ISBN 0-7385-2045-4

Published by Arcadia Publishing,
an imprint of Tempus Publishing, Inc.
3047 N. Lincoln Ave., Suite 410
Chicago, IL 60657

Printed in Great Britain.

Library of Congress Catalog Card Number: 2002112246

For all general information contact Arcadia Publishing at:
Telephone 843-853-2070
Fax 843-853-0044
E-Mail sales@arcadiapublishing.com

For customer service and orders:
Toll-Free 1-888-313-2665

Visit us on the internet at http://www.arcadiapublishing.com

CONTENTS

ACKNOWLEDGMENTS

The images in this book were not gathered from a single collection; rather they were searched out from a variety of sources including archives, libraries, municipal offices, and private parties. I would like to thank all the people who contributed by lending photos, expertise, and support. These include Brenda Davidson, East Lansing Public Library; Mark Harvey, State of Michigan Archives; Fred Honhart, Michigan State University Archives & Historical Collections; and Tom Wibert, East Lansing Police Department. Photographs from individual contributors are credited in parentheses.

I would also like to give a special thank you to Ron Springer of the City of East Lansing for his invaluable help in locating and identifying photographs. Finally, I would like to offer my appreciation to the East Lansing Historical Society for their support of this project and their dedication to documenting the history of East Lansing, Michigan.

All material research and photographic material collected during this project is deposited at Michigan State University Archives and Historical Collections. Specific information about photographs can be obtained there through the author.

INTRODUCTION

The area that would become East Lansing, Michigan began as a crossroads of Indian trails and encampments. The State of Michigan chose this forested, undeveloped area to be the site of a new college devoted to agricultural science in 1855. A surrounding community soon sprang up as the result of that decision. Collegeville, as the first off-campus development was called, eventually expanded and organized to become the City of East Lansing. It would be impossible and undesirable to deny the symbiotic relationship that exists between the city and the college. However, in the last one hundred years, East Lansing has grown into a diverse and distinct community of its own. *East Lansing, Collegeville Revisited* depicts that growth.

The idea behind this book was to gather photographs from the community instead of relying on the items already collected in a single archive or library. The methodology was simple: inform as many people as possible about the project and ask for them to lend (temporarily) photographs and items that documented East Lansing's history. Articles were written in several local papers, speeches were made to community and historical groups, and visits were made to many homes to discuss the project. I chose this method for gathering the items with an ulterior motive in mind, though; I wanted to create dialogue with members of the community about how important individual contributions are to documenting a community's history. History consists of the stories of people, places, and events, and while some people are players in national or world history, we are all part of a family and community history, and we all have something to contribute.

This book takes a chronological approach to depicting the development of East Lansing, Michigan. It is not meant to be a comprehensive history, so much as an interesting photo chronicle. Some important events were not included if no accompanying picture was available, and in some cases there were too many photos of one subject to include them all. Nevertheless, the images presented here illustrate a strong community that has an interesting story to tell.

The book is divided into four chapters or time frames. *The Beginning* has the earliest photos depicting the area in a wilderness state through the establishment of the city in 1907; *The City Grows into a Community* documents the development of schools, religious activities, clubs and

organizations, transportation and roads, the downtown business district, and municipal services through the city's first major expansion after World War II; *A Modern Town* depicts the city's response to urbanization, suburbanization, civil and social strife, and the drive to maintain a sense of community; and the final chapter, *Eye Toward the Past, Change Toward the Future* reveals new projects that embrace the historic nature of the city while preparing the way for East Lansing's second century.

One
THE BEGINNING

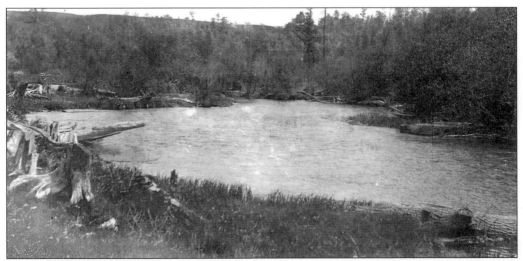

THE "WILD" RED CEDAR RIVER, C. 1855. The seeds for East Lansing, Michigan were planted in 1855 when the state of Michigan purchased 676.57 acres of land for the site of the new Michigan Agricultural College. The land was mostly wild and uncleared, but the river running through it had appealed to Indians for centuries. (MSU Archives and Historical Collections, UAHC.)

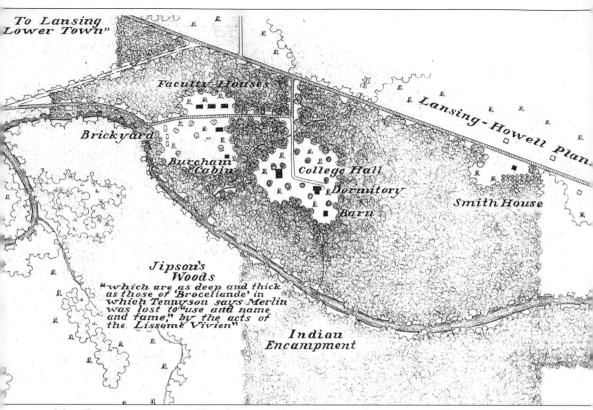

On the map:

To Lansing Lower Town"

Faculty Houses

Brickyard

Burcham Cabin

College Hall

Dormitory

Barn

Smith House

Lansing-Howell Plan.

Jipson's Woods

"which are as deep and thick as those of 'Broceliande' in which Tennyson says Merlin was lost to "use and name and fame," by the acts of the Lissome Vivien"

Indian Encampment

MAP REPRESENTING THE KEY SITES OF FIRST HUMAN SETTLEMENT. The sparsely populated college area was just three short miles from Lansing, Michigan's capital city. The first white resident in the area, Robert Burcham, settled near the river where the MSU Music Building now stands and created a thriving trading business with the nearby Indian encampment in 1849. (UAHC.)

RURAL CABIN, 1901. Although this cabin dates from a generation after Burcham's, it was just a short walk from the campus area and represents the rural setting that could be found from the mid-19th century into 20th century.

MICHIGAN AVENUE LEADING FROM THE MICHIGAN CAPITOL BUILDING. In 1849, this road from the Capitol building, then known as Middletown or Capitol Road East, was extended toward the college. Later renamed Michigan Avenue, it was eventually redesigned and extended to intersect with Grand River Road three miles to the east. (UAHC.)

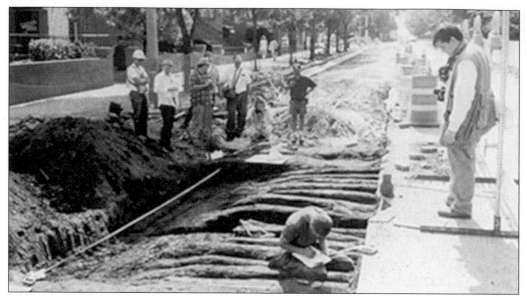

PLANK ROAD DISCOVERY, 1995. One of the oldest roads in the state, built following earlier Indian made trails, Grand River Road extends East-West across Michigan. By 1853, planks were laid to smooth the ride and to make the swampy land passable by stagecoaches. The improved section of Grand River Road was renamed the Howell-Lansing Plank Road during this time period. Modern road construction uncovered remnants of the old plank road in 1995. Here the State Archaeologist, John Halsey, documents the discovery. (Dean L. Anderson, Office of State Archaeologist.)

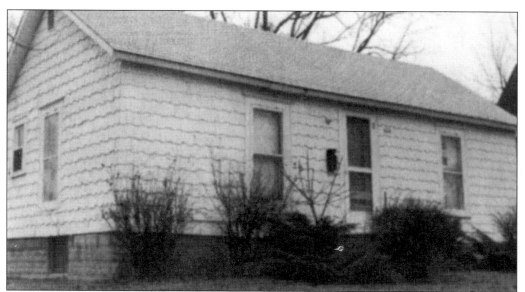

PROCTOR TOLL GATEHOUSE, 1973. Toll Houses were erected approximately every few miles to help pay for the maintenance of the roads. This toll house, located on the road between Lansing and Howell, was built in 1851 by Asa Proctor. It was moved in 1907 from its original location to Hagadorn Road and was used as a residence until 1973. The house was then moved to Meridian Township for restoration and placed on the State Register of Historic Places as the only remaining toll house structure from the Plank Road era. (Friends of Historic Meridian.)

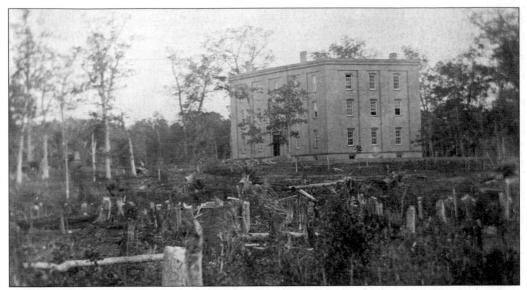

FIRST BUILDING, 1856. Once the State approved the land purchase for the new college, structures had to be built. College Hall, the first building in the United States constructed for agricultural science education, was East Lansing's first building too. It served not only as a classroom, but also as a chapel and community meeting space. Note the picture shows the land-clearing in progress. (UAHC.)

LAND-CLEARING CONTINUES, 1906. Clearing college land of trees for building and farms continued for many years after the founding of the college, as this 1906 picture shows. (UAHC.)

THE ELMS. A double row of American elm trees were planted in 1878 at the northern border of the campus along Michigan and Grand River Avenue. As the trees grew, they created a boundary line between the campus and the new town across the street. The "Elm Walk" became one of the favorite vistas for area residents. (UAHC.)

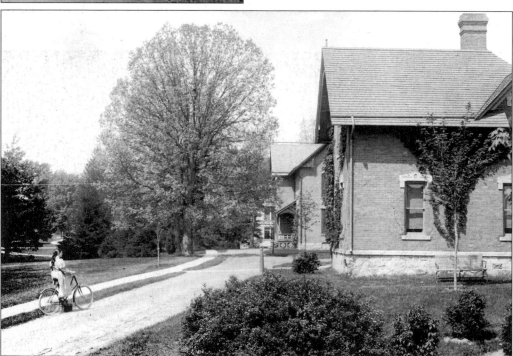

FACULTY ROW. Housing was provided for the faculty and their families on campus. Four faculty houses were built in 1857 and more were added as needed until 1885. (UAHC.)

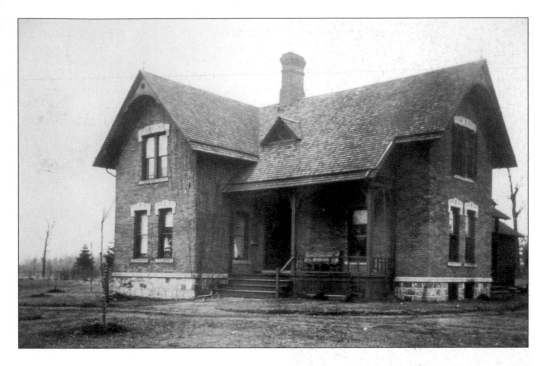

FACULTY ROW HOUSE #9, 1884, FACULTY ROW HOUSE #9, 2000. As the college grew and alternative off-campus housing appeared, the faculty residences were replaced with more useful buildings. Number 9, built in 1884, is the only one that has survived. It was moved to 217 Beech Street in East Lansing and remains the oldest residence within the original city limits. (City of East Lansing—EL.)

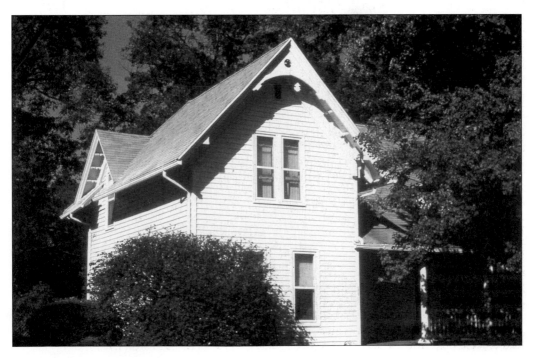

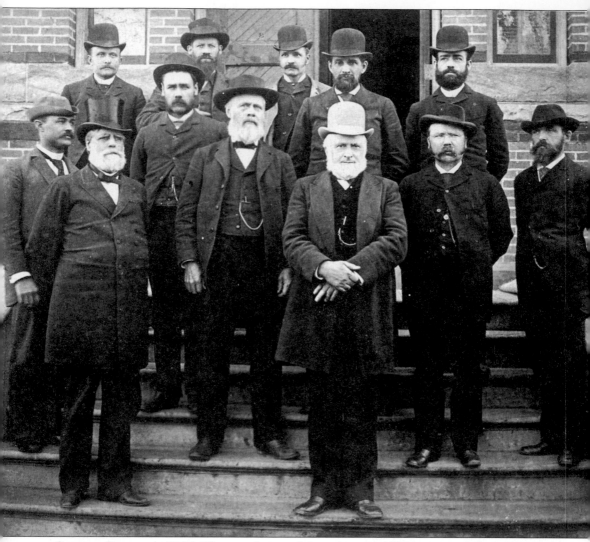

COLLEGE FACULTY, 1888. The population of the campus in 1857 comprised about 70 students and less than 10 faculty members. The Unincorporated Village of Agricultural College, Michigan was more or less self-contained for a few years, but as the popularity of the college grew, women were admitted (1870) and the course of study expanded. When this picture was taken, there were about 340 students and over 30 faculty and staff. (UAHC.)

FACULTY FAMILIES, C. 1890. The faculty row homes were spacious and also had an area in the back for a garden or stable. In this picture, children of the faculty play with the animals in the back yard. (UAHC.)

FARMING FAMILIES, C. 1890S. Farming was still a way of life in the Mid-Michigan area. Many farms existed around the campus; some were used for scientific experimentation, some were local businesses, and some were for family sustenance. Here a family works together to bring in the crop on a local farm. (UAHC.)

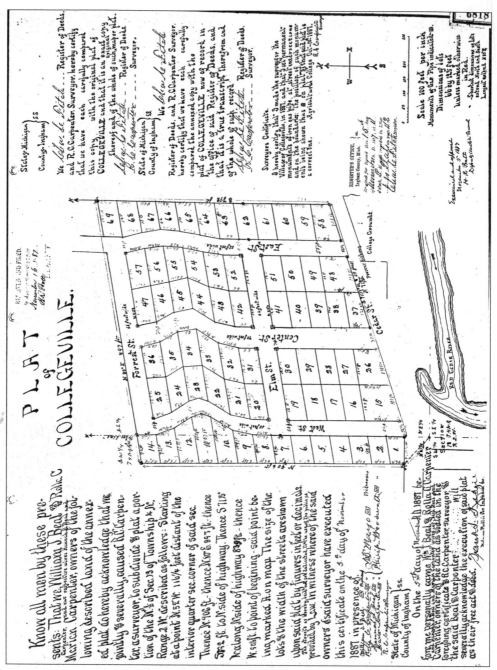

COLLEGEVILLE, 1887. As the college grew, the pressing need for more housing prompted professors William J. Beal and Rolla C. Carpenter to buy, subdivide, and plat land for the area's first formally-developed housing community. They named the area Collegeville. The area fronted Michigan Avenue and ran two blocks north on West Street (now Harrison), then two blocks east, along Forrest Street (Oak), and back south on East Street (Beal). Unfortunately, the development never appealed to the college faculty. Not only was it considered too far away (a quarter mile!), but no water or sewer systems had been built. The area did become popular with laborers who could build small, inexpensive houses.

18

ROLLA C. CARPENTER, C. 1885. Professor of Mathematics and Engineering, Rolla C. Carpenter surveyed and prepared the plat for the Collegeville area. He is shown here with his surveying equipment. (UAHC.)

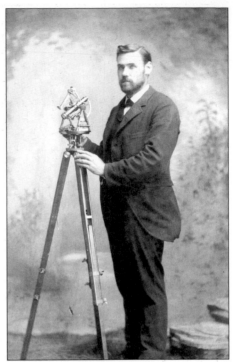

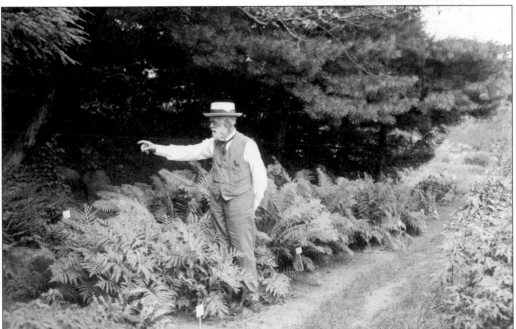

WILLIAM J. BEAL, IN THE ARBORETUM, C. 1900. Professor of Botany and Horticulture, William J. Beal worked at the college from 1871 to 1910. He is considered a national leader in the development of botany, horticulture, and plant genetics experiments. He is generally credited with developing hybrid corn. Locally, his experiments dotted the campus with beautiful natural areas including an arboretum, a pinetum, and the famous Beal Gardens. It was primarily his land that became Collegeville and its later additions. (UAHC.)

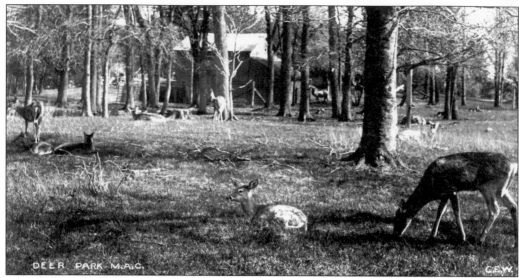

ARRBORETUM & DEER PARK, C. 1898. Beal's arboretum fronted Grand River Avenue, roughly where the Union Building stands today, and was planted in 1873 to be an experimental showcase for natural growth. In 1898, two acres of land were fenced off to house deer and elk obtained from Belle Isle Park in Detroit. The deer park existed through 1915, when eventually the animals died off and the natural area succumbed to campus expansion. (UAHC.)

OFF-CAMPUS HOUSING, C. 1891. The same kind of housing shortage that existed for faculty also existed for students. A variety of boarding houses and rooms-for-rent became available in the 1890s. This is a photo of the Bradford Cottage, one-half mile from campus on Michigan Avenue. It was torn down in 1928 to build a small golf course. (UAHC.)

Beal's Addition and the College Delta, 1895. The continuing demand for faculty and student housing forced further development. This happened very quickly starting with Beal's addition of the property directly north of Collegeville. Within four years, the land directly west of Collegeville was platted to complete the College Delta. This land was originally part of the college and the site of many of Beal's scientific experiments. When Michigan Avenue was extended eastward, it severed this section from main campus. The land north and east of the Delta along Grand River was also developed and would soon become the heart of the business district.

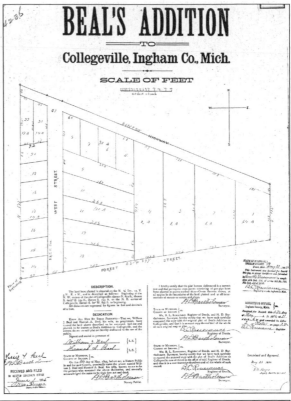

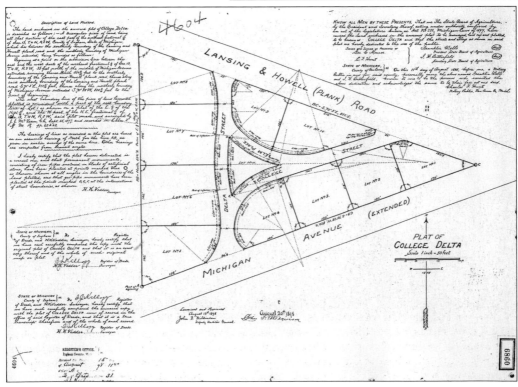

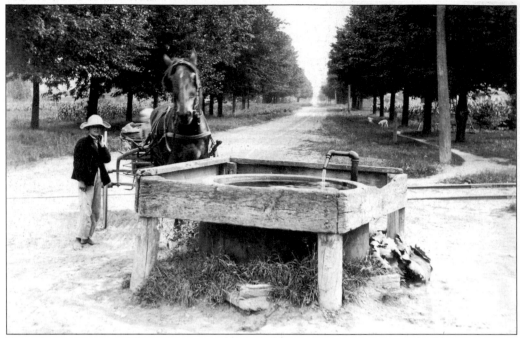

REST STOP, C. 1897. This is a cistern along Michigan Avenue. It was supplied by water pipes leading from the college water supply. These pipes provided water to the Delta area until 1908. (UAHC.)

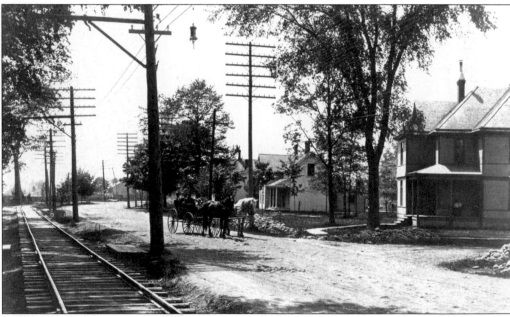

STREETCAR LINES, C. 1905. A streetcar (or trolley) line was extended from downtown Lansing along Michigan Avenue to Harrison Road in 1894. The line stopped at the edge of campus because it was thought that troublemakers would otherwise be tempted to visit the campus. It was also an attempt to keep students from visiting Lansing saloons. The streetcar was open air, as can be seen in the next picture. (UAHC.)

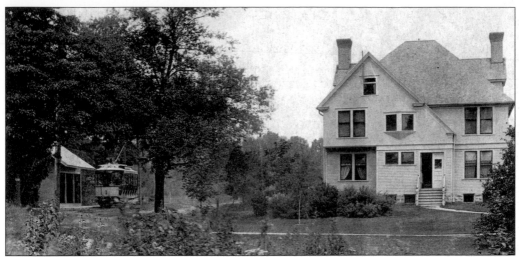

WAITING STATION, 1901. Several factors contributed to the streetcar finally being extended onto college grounds. The change of the college vacation to summer, as well as the increase of women students who attended a special women's course, prompted many to complain about the long, snowy walk and extended wait in the cold for the trolley. The administration finally approved a line that entered campus directly across from Evergreen Street The small station is on the left. Grand River Avenue is in the distance through the trees. (UAHC.)

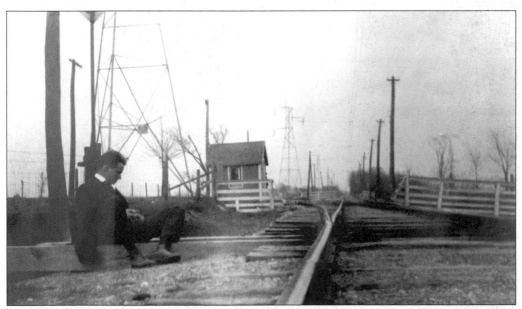

WAITING FOR THE TRAIN ON TROWBRIDGE ROAD, 1918. The Lansing and Lake Michigan Railroad Company built a railroad line in 1871 across south Harrison Road, and the Grand Trunk Railroad built the Trowbridge Junction in 1876. This was often used by those in the area traveling long distances or to ship freight. The center of East Lansing railroad travel, it still exists in the same place today. (Marilyn Ledeburgh.)

HARRISON FAMILY HOUSE. This house was built by the prominent Harrison family in 1865 at 1111 Michigan Avenue. It was demolished in 1964 to accommodate the widening of Michigan Avenue.

Harrison property and ventures helped shape the future of East Lansing. Joel "Ping" Harrison owned two of the first businesses in town. In 1896, he built a boarding house called Harrison Hall (or the "white elephant"), and in 1898 he built a tobacco and candy shop on the hill west of the current Beal Entrance to campus. (EL.)

OLDEST EXISTING COMMERCIAL BUILDING, 2002. Information about this building on Harrison Road indicates that it may have been closer to Michigan Avenue but was moved back approximately 500 feet to its current location. Today this building houses a hardware store, but it may have originally been a grocery store c. 1880. This is the oldest existing commercial building in East Lansing. (Whitney Miller.)

CAMPUS CAFE, C. 1909.
Charles Chase built the first
building in today's
downtown East Lansing in
1903, near Abbott Road on
Grand River Avenue.
Always known as the Chase
Block, it housed the College
Cafe owned by Edd Hicks.
In 1908, A.C. Bauer
(brother to the town's
doctor) opened the College
Drug Store next door and
bought out the College
Cafe in 1911. This building
stood until 1939. (East
Lansing Public Library.)

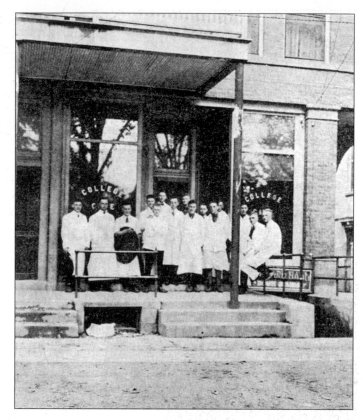

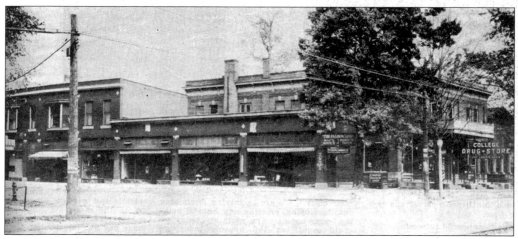

CHASE BLOCK, C. 1919. Charlie Chase expanded his "block" when he built a group of
buildings facing Abbott Road. The building directly at the corner of Abbott Rd and Grand
River Avenue was now a one-story building occupied by Hurd's Men Shop. The next building
on Abbott was the town's first theater, called the ELMAC (East Lansing Michigan Agricultural
College). It is just visible at the far left of the picture. (East Lansing Public Library.)

EAST LANSING BILL BECOMES LAW TODAY

FIRST ELECTION OF THE NEW CITY PROBABLY WILL BE MAY 21.

DR. BEAL FOR MAYOR

MENTIONED AS ONE WHOM PEO-PLE THERE WOULD LIKE TO HONOR WITH ELECTION

Who'll be mayor of East Lansing? This will be a question that the res-idents of that city will soon have to determine. The incorporation bill be-comes law today with Gov. Warner's signature. It provides that the first election should be held on the second Tuesday in May, but inasmuch as the necessary ten days' notice cannot be given now, it will be called for a later time, possibly the third Tuesday of the month. Dr. William J. Beal, Noah Snyder, Robert Kendall and James D. Towar are named the board of reg-istration for the first election, and they will call the election. The registra-tion board will meet on the Saturday preceding election.

Dr. Beal is mentioned as one whom the people of the new city would like to honor with election as mayor. He is recognized as the oldest resident of the island

EAST LANSING, 1907. Land belonging to the college and the surrounding community was split between the jurisdiction of Lansing and Meridian Townships, which continually caused political conflicts and bureaucratic red-tape. Around 1906, citizens began considering the idea of becoming their own city. A proposal went forth to the state government to approve a charter for a new city called College Park. The Michigan House of Representatives approved it, but the Senate decided that a better name would be East Lansing. On May 8, 1907 Governor Fred Warner made it official. East Lansing was now an independent city. This was the announcement in *The State Republican* on the day of the signing.

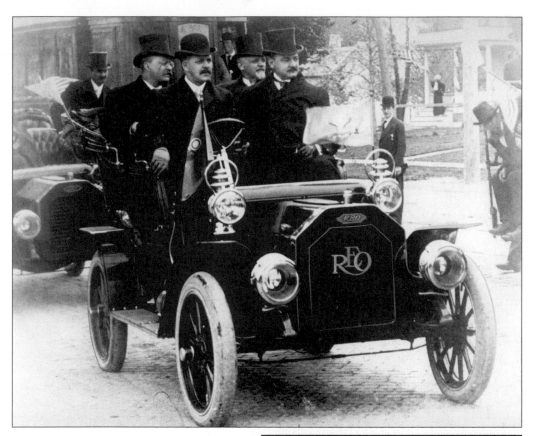

PRESIDENTIAL VISIT, 1907. On May 31, 1907, on the occasion of the college's semi-centennial (50-year) anniversary, East Lansing and Michigan Agricultural College hosted a visit from Teddy Roosevelt. In this famous picture, Roosevelt rides with Jonathan Snyder, President of M.A.C., as Ransom E. Olds drives along Michigan Avenue. (UAHC.)

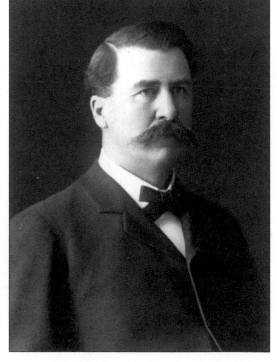

CLINTON D. SMITH, C. 1907. Professor Clinton Smith was elected mayor of the new city on June 18, 1907. He opened the first city council meeting a week later, and his first order of business was to develop a plan to raise funds. Rejecting a tax levy as his first official act, he put up $300 of his own money until previously paid tax money could be recovered from Lansing and Meridian Townships. (EL.)

SWAMP LAND, C. 1900. In the City's first few years, the items of most importance were addressed: water, sewer, sidewalks, streetlights (electricity had already been introduced in 1897), and swamp drainage. Much of the area was a natural swamp. The college had eliminated the swamp areas on campus, but East Lansing still needed work. This view looks northeast towards Grand River Avenue when East Lansing was once all swamp land. The photo was taken from the recently constructed Women's Building, now Morrill Hall. (Marilyn Ledeburgh.)

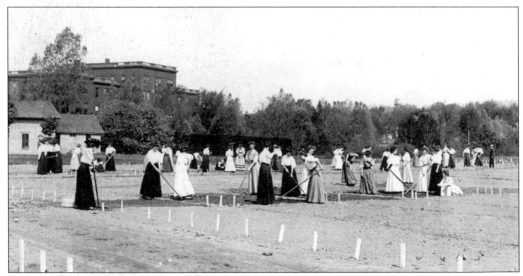

WOMEN STUDENTS TILLING THE GARDENS, C. 1909. This is the same plot of land, now drained, as pictured in the previous photo. Morrill Hall is the large building on the left. At the top of the tree line in the right-center of the photo, East Lansing's first water tower can be seen. (UAHC.)

28

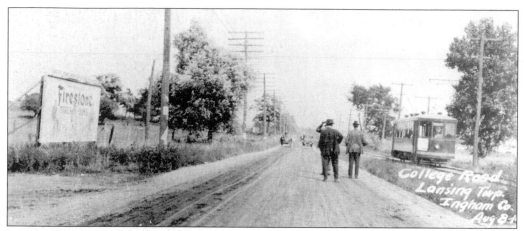

TRAFFIC! C. 1910. Land development and population exploded once the city became incorporated and city services were provided. Here automobiles and streetcars provide access between East Lansing and Lansing. (State of Michigan Archives.)

CHASE NEWMAN, C. 1911. Chase Newman, one of the city's first alderman, developed a system of numbering buildings within the city. In 1913, he copyrighted the first official map of the City of East Lansing. This map can be seen on the following page. East Lansing was now a city, but in name only. All the things that constitute a city: roads, stores, parks, churches, schools, police, fire service, postal service, and above all a sense of community had yet to come to fruition. The new city would waste no time in getting to work. (UAHC.)

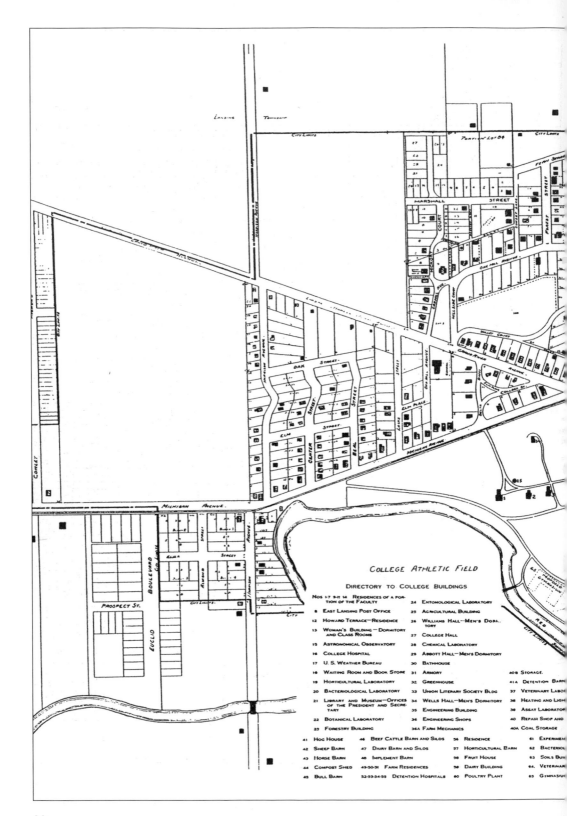

COLLEGE ATHLETIC FIELD

DIRECTORY TO COLLEGE BUILDINGS

Nos 1-7 9-11 14 RESIDENCES OF A PORTION OF THE FACULTY

8 EAST LANSING POST OFFICE
12 HOWARD TERRACE—RESIDENCE
13 WOMAN'S BUILDING—DORMITORY AND CLASS ROOMS
15 ASTRONOMICAL OBSERVATORY
16 COLLEGE HOSPITAL
17 U. S. WEATHER BUREAU
18 WAITING ROOM AND BOOK STORE
19 HORTICULTURAL LABORATORY
20 BACTERIOLOGICAL LABORATORY
21 LIBRARY AND MUSEUM—OFFICES OF THE PRESIDENT AND SECRETARY
22 BOTANICAL LABORATORY
23 FORESTRY BUILDING

24 ENTOMOLOGICAL LABORATORY
25 AGRICULTURAL BUILDING
26 WILLIAMS HALL—MEN'S DORMITORY
27 COLLEGE HALL
28 CHEMICAL LABORATORY
29 ABBOTT HALL—MEN'S DORMITORY
30 BATHHOUSE
31 ARMORY
32 GREENHOUSE
33 UNION LITERARY SOCIETY BLDG
34 WELLS HALL—MEN'S DORMITORY
35 ENGINEERING BUILDING
36 ENGINEERING SHOPS
36A FARM MECHANICS

40B STORAGE
41A DETENTION BARN
37 VETERINARY LABOR
38 HEATING AND LIGHT
39 ASSAY LABORATOR
40 REPAIR SHOP AND
40A COAL STORAGE

41 HOG HOUSE
42 SHEEP BARN
43 HORSE BARN
44 COMPOST SHED
45 BULL BARN

46 BEEF CATTLE BARN AND SILOS
47 DAIRY BARN AND SILOS
48 IMPLEMENT BARN
49-50-51 FARM RESIDENCES
52-53-54-55 DETENTION HOSPITALS

56 RESIDENCE
57 HORTICULTURAL BARN
58 FRUIT HOUSE
59 DAIRY BUILDING
60 POULTRY PLANT

61 EXPERIMEN
62 BACTERIOL
63 SOILS BUI
64 VETERINAR
65 GYMNASIUM

30

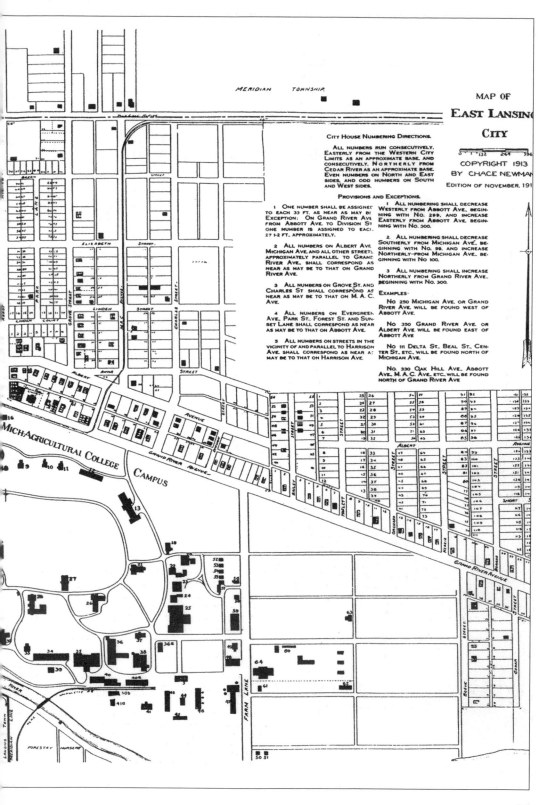

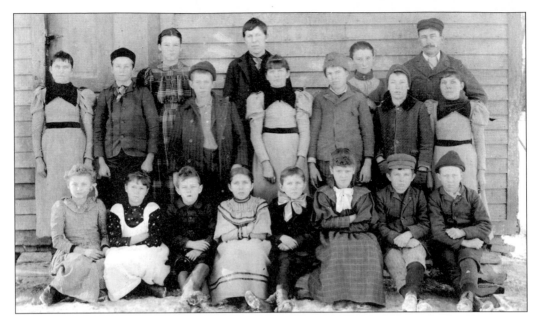

DISTRICT SCHOOL (MARBLE SCHOOL) CLASS PICTURE, 1894. The development of a school system was the most necessary service for the early area residents—so much so that the East Lansing School system was actually established before the city itself. Before incorporation, the city straddled two different townships, and local children had to attend one of the distant, existing schools that served mostly farmers. This school stood until 1911. Two other Marble Schools have been built. The one below is now a pre-school center and a modern Marble Elementary School is across the street. (UAHC.)

"THE BAND LEADER" AT THE SECOND MARBLE SCHOOL, 1938. (Mr. & Mrs. John Wales.)

Two
THE CITY GROWS
INTO A COMMUNITY

MISS MINA WALSH AND HER STUDENTS AT THE CHAMPION SCHOOL, C. 1924. The Brickyard School, built in 1859 in Lansing Township, was located near today's Frandor Shopping Center. The Carl School near the corner of Saginaw and Lake Lansing Roads was built in 1860. Marble School was built in 1862 when Hagadorn Road residents organized to petition Meridian Township for a school. Finally, the Harrison Road School (or the Champion School) was built in 1869 to serve the people that lived in the Trowbridge area. This school was located at the corner of Mt. Hope and Harrison and stood for 55 years until 1924. None of these areas were within the 1907 East Lansing city limits. (EL.)

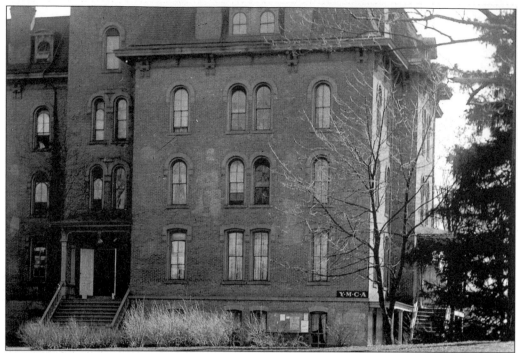

WILLIAMS HALL—YMCA, c. 1891. In 1900, the two townships were petitioned to allow a new school district to serve the college and surrounding area. A temporary school was set up in the YMCA room of Williams Hall on campus. Although contested, the district was approved April 10, 1901. Thus, the school district actually pre-dates the formation of the city. (UAHC.)

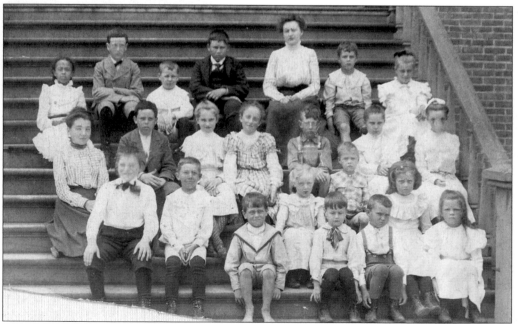

EAST LANSING SCHOOL DISTRICT'S FIRST STUDENTS, ON THE STEPS OF WILLIAMS HALL, 1901. (UAHC.)

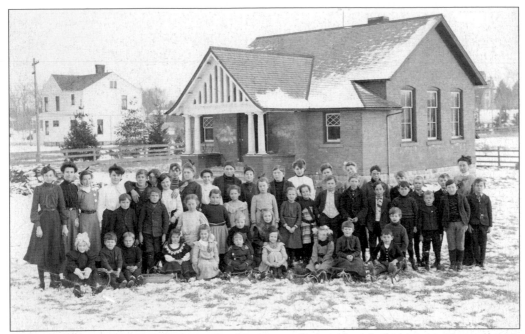

CENTRAL SCHOOL, 1903. The new school house was built and ready for business December 30, 1901. Central School was on the north side of the Delta, at Grand River and Hillcrest. The population quickly outgrew the school and it was enlarged several times, forcing temporary classes to be held all over the city. (UAHC.)

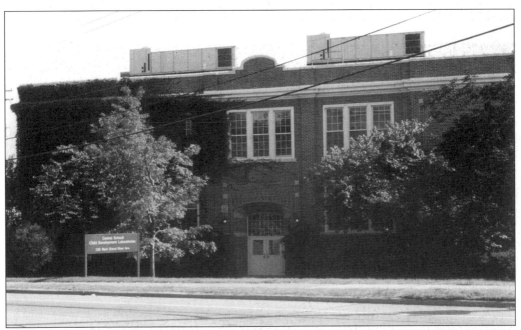

CENTRAL SCHOOL, 2002. A new Central School was finished in 1917 in a Neo-Classical style. It was designed by renowned Michigan architect Edwyn A. Bowd. Central School provided the first high school classes and eventually developed a college-preparatory course and a vocational course. It was closed in 1984 and is now used by Michigan State University. (Whitney Miller.)

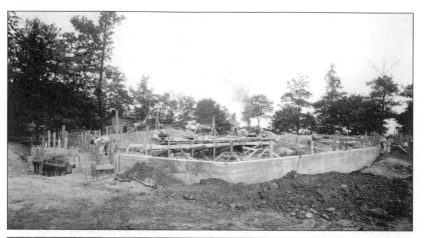

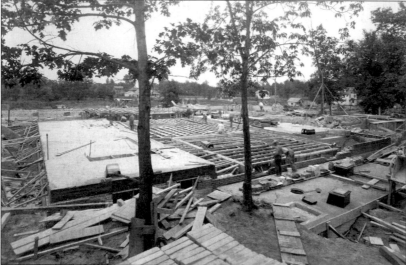

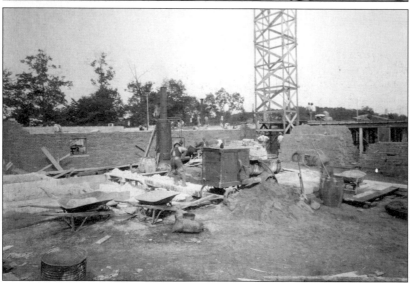

CONSTRUCTION OF EAST LANSING HIGH SCHOOL, 1926. The original East Lansing High School is one of the landmark buildings in town. It was built to not only ease overcrowding of the existing schools, but it was also a showpiece for the community with large, modern classrooms and athletic facilities. Once opened, East Lansing was able to join the "Little Seven League" which sponsored high school athletic contests. Here are a series of pictures showing its construction, which lasted from June through September 1926 on the Abbott Road site. At the time of construction, the school was just north of the city boundary. (EL.)

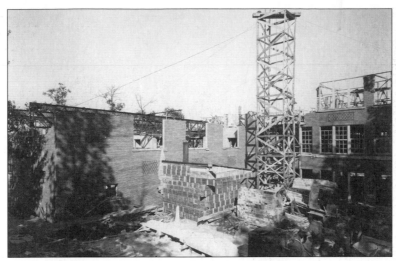

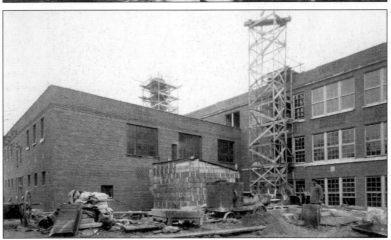

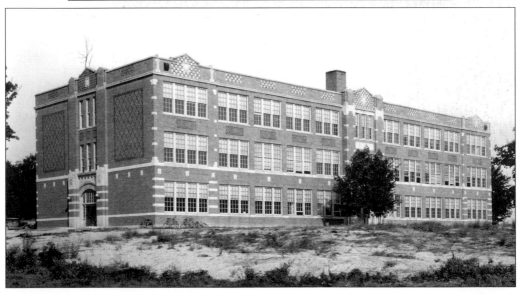

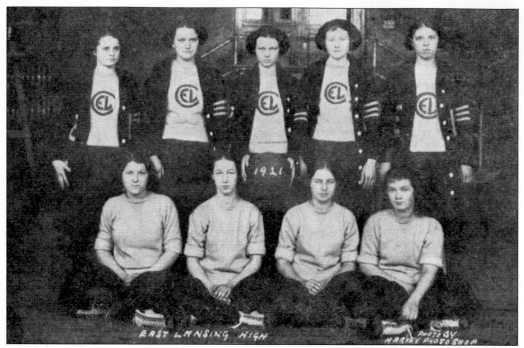

CHAMPIONSHIP GIRLS BASKETBALL TEAM, 1921. East Lansing residents strongly supported high school sports for boys and girls. The girls' high school basketball team won the state championship for East Lansing Central School two years running, 1919–1920 and 1920–1921. They were reportedly so good because they used boys' rules in practice to hone their skills. (East Lansing Public Library.)

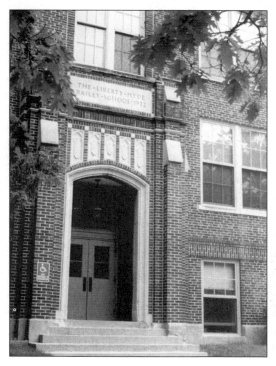

LIBERTY HYDE BAILEY SCHOOL. The Bailey School was built in 1922 to ease the problems of increasing enrollment. It served the burgeoning east side of the city. It was named after Dr. Liberty Hyde Bailey, the famous horticulturist, who was both a student and a professor at Michigan State College. (Whitney Miller.)

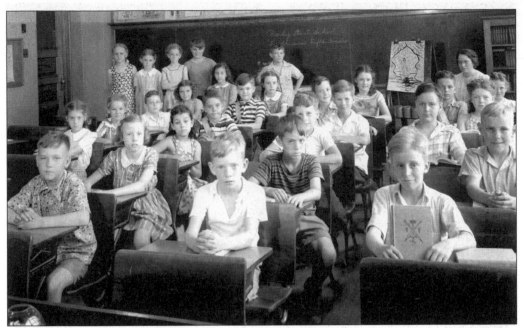

BAILEY CLASSROOM, 1940. This is the classroom and students of the fourth and fifth grade, a combined class in the Bailey School. (Clarice Thompson.)

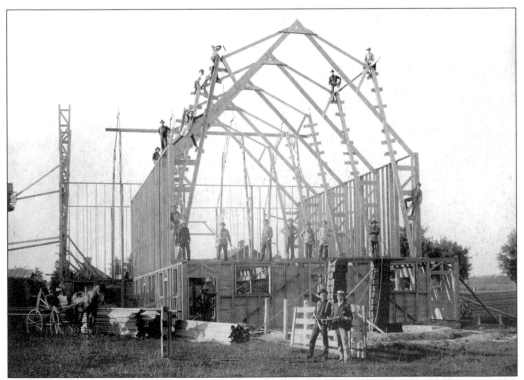

BARN RAISING, C. 1900. The local community included a diverse population including students, faculty, and farmers who came together here to help with a new innovative barn-raising process. (UAHC.)

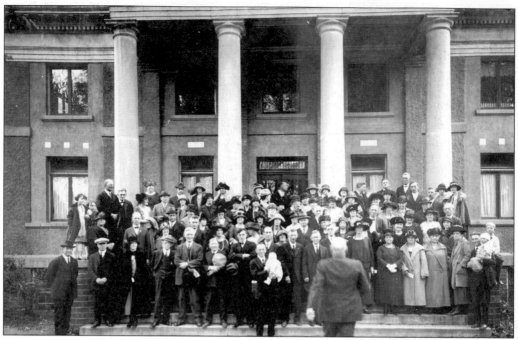

PEOPLE'S CHURCH CONGREGATION, C. 1920. When the college was established, the first building built was College Hall. It served the area's religious needs by housing a small chapel. By the time the city was established, the community clearly needed its own house of worship. The People's Church was organized in 1907 as a congregational organization originally representing eleven different denominations. It first met at the college Armory. The original People's Church building was completed in 1911 and cost $17,000. It was located just east of Abbott Road on Grand River Avenue. (Kent Wilcox.)

NEWELL A. McCUNE FAMILY, C. 1902. Pastor McCune, an MSC graduate, was a popular orator and he attracted many people to his services. A temporary building was erected on the vacant lot east of the church to hold the overflow crowd. This building was nicknamed "McCune's Garage." He was the Pastor of People's Church from 1917 until 1949. (EL.)

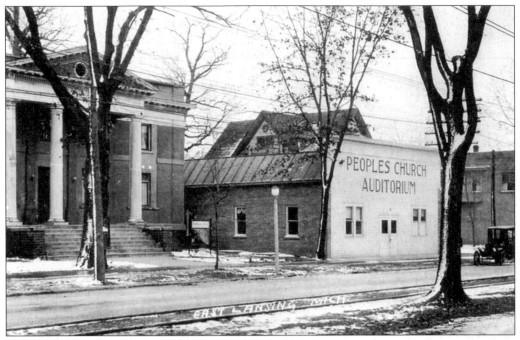

MCCUNE'S GARAGE, 1922. (EL.)

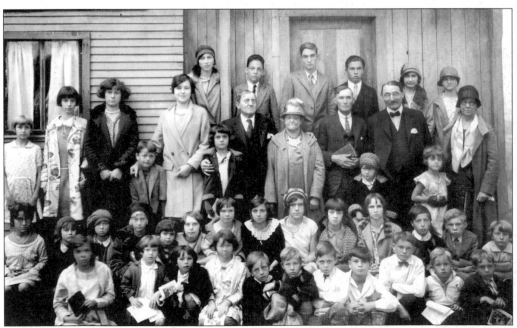

SUNDAY SCHOOL, C. 1924. The lack of adequate facilities required that Sunday school be held somewhere other than the church building. This is a Sunday school class held at Marble School. N.A. McCune is on the right with the bow tie. (Kent Wilcox.)

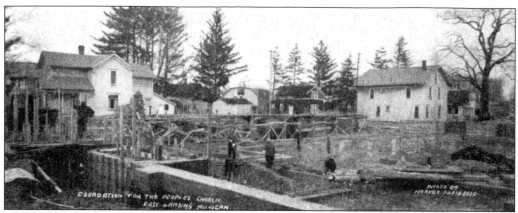

NEW PEOPLE'S CHURCH CONSTRUCTION, C. 1924. The growth in the community, the popularity of religious activities, and the need for a community center prompted the congregation to raise money for a new church building. Money was raised from all over the country and on November 24, 1923 the cornerstone was laid. Moving a block west and opening in May 1926, People's Church continued to be the only church in town for over generation. Not only did it attend to people's religious needs, but the new building provided large spaces for many social and community activities, including serving as a schoolhouse and library. (UAHC.)

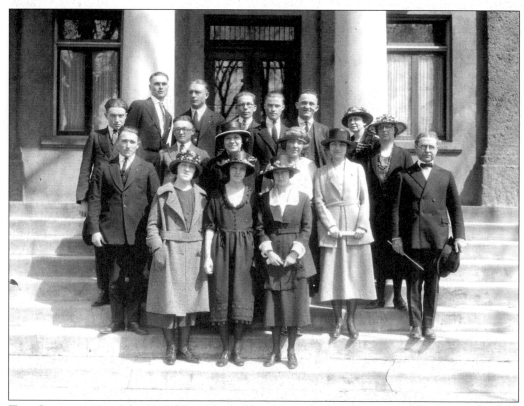

THE CHOIR, 1922. The People's Church Choir was organized by Music Director Taylor (on right with baton) because of the community's insistent desire to have a choir composed of local people. Prior to the formation of this choir, out-of-town singers had to be located and invited weekly. (UAHC.)

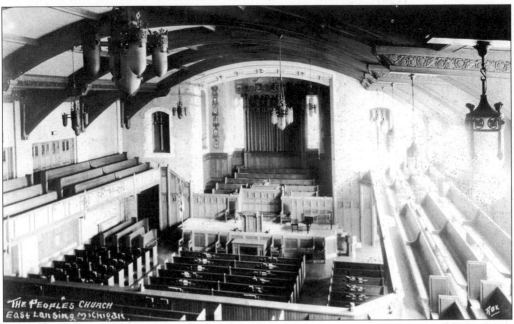

PEOPLE'S CHURCH INTERIOR, C. 1926. The large, beautiful interior of the new church was exactly what the townspeople had hoped for. (UAHC.)

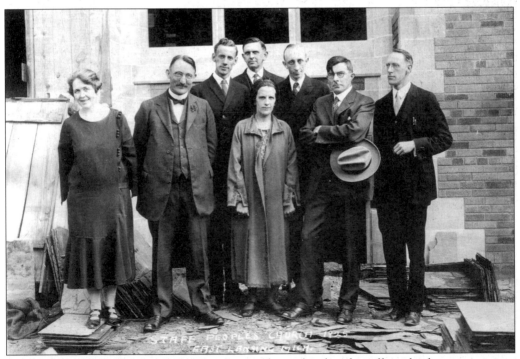

PEOPLE'S CHURCH STAFF, 1925. This picture shows the church staff amidst the construction. N.A. McCune is on the left with bow tie. (Kent Wilcox.)

CEMETERY SERVICES. East Lansing has never had an official cemetery within city limits. The old Okemos Cemetery, a small area just over the border on Grand River Avenue, was used primarily between the 1860s and 1920s. Most of the names are of Meridian Township origin. However, some East Lansing residents are buried there, including J.D. Tower, who wrote a comprehensive city history in 1933. (Whitney Miller.)

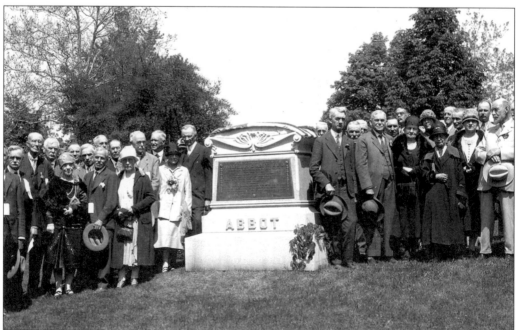

MT. HOPE CEMETERY, 1928. A primary burial location for East Lansing residents is the Mt. Hope Cemetery located southwest of the city between the college and Lansing. This an anniversary memorial service for T.C. Abott, who was president of MSC from 1862 to 1884 and for whom Abbott Road is named. (UAHC.)

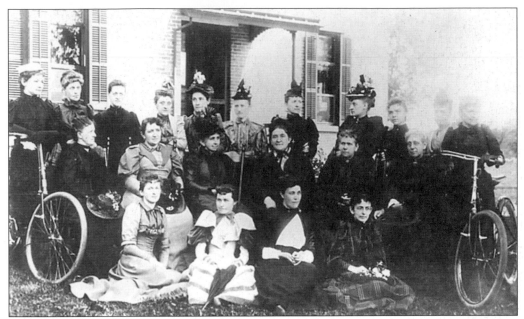

MAC FACULTY LADIES, 1892. Religious, social, and intellectual clubs were popular in East Lansing. This was especially true for women. The women of East Lansing had originally been faculty wives, but later, as more women attended the college and moved into the community, women organized various activities for themselves. One of the most popular was the East Lansing Women's Club, originally known as the M.A.C. Women's Club in 1903. The women of the club raised money for community needs, did charity work, debated intellectual issues of the day, and provided community entertainment. (UAHC.)

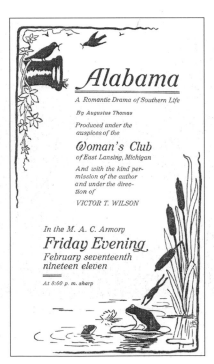

Alabama

A Romantic Drama of Southern Life

By Augustus Thomas

Produced under the auspices of the

Woman's Club
of East Lansing, Michigan

And with the kind permission of the author and under the direction of

VICTOR T. WILSON

In the M. A. C. Armory
Friday Evening
February seventeenth nineteen eleven

At 8:00 p. m. sharp

EAST LANSING WOMEN'S CLUB FLYER, 1911. (UAHC.)

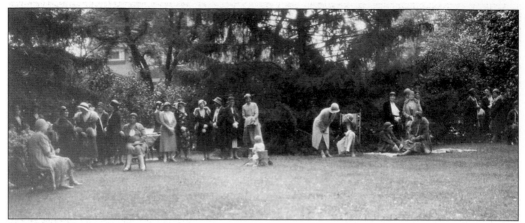

LAWN PARTY, C. 1920s. This lawn party was held at 258 Michigan Avenue as a mixer for the college girls and the ladies of the community. (UAHC.)

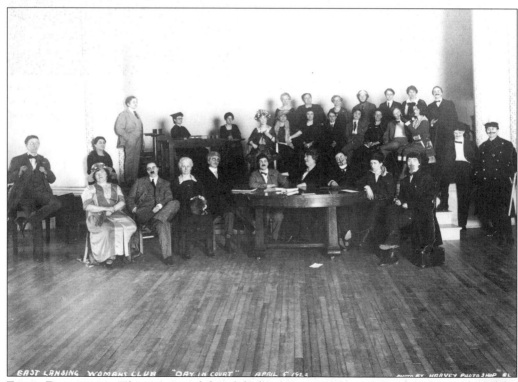

EAST LANSING WOMANS CLUB "DAY IN COURT" APRIL 5 1923 PHOTO BY HARVEY PHOTO SHOP EL

FOLLY DAY, 1923. The women of the club dress up to perform a parody of the men in the community, in a play called *Day in Court*. (UAHC.)

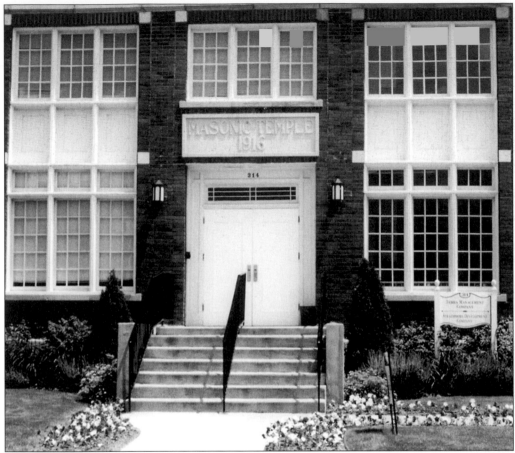

MASONIC TEMPLE. Men also enjoyed participation in service and social organizations. This building was built on M.A.C. Avenue by the Masons in 1916 when there were only a few commercial buildings in the downtown. It is on the National Register of Historic Places. (Whitney Miller.)

Vaudeville Ticket
10 Cents
EAST LANSING MASONIC FAIR
DECEMBER 6-7-8-9, 1916

Good also for one chance on **20608**
FIVE BIG PRIZES

Nº 20608

COUPON - 10c

Good for one chance on Five Big Prizes

Keep this until the drawing Dec. 9, 1916

MASONIC FAIR, 1916. It is unknown exactly where this fair took place, although it's possible it was near the Frandor area just outside city limits, where the circus performed when it came to the area. (UAHC.)

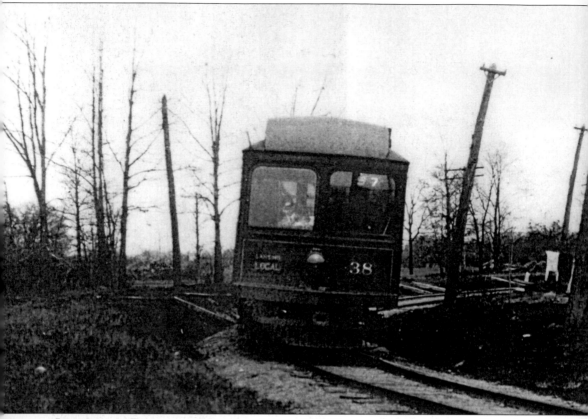

INTERURBAN TURNS FROM BURCHAM ONTO M.A.C. AS IT SPEEDS THROUGH EAST LANSING, c. 1915. While the streetcars can be credited with helping East Lansing develop by providing reliable transportation to and from Lansing, they soon became inadequate. Local people needed to travel faster, and to more places than ever before; the interurban satisfied that need. Larger and faster than the streetcars, the Interurban line was built in 1905 and extended north on M.A.C. Avenue, curving onto Burcham Drive and going eastward out to Pine Lake (Lake Lansing) and onward to Owosso. The interurban line was closed in 1929 when buses and autos became more popular. (Louis Potter, E.L. Historical Society.)

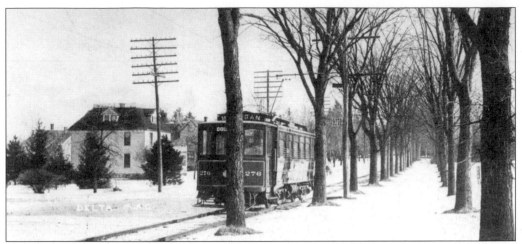

INTERURBAN PASSES THE DELTA AREA, C. 1910. This picture shows the interurban as it travels along Michigan Avenue next to the elms. The campus is on the right side and the College Delta area is on the left. (UAHC.)

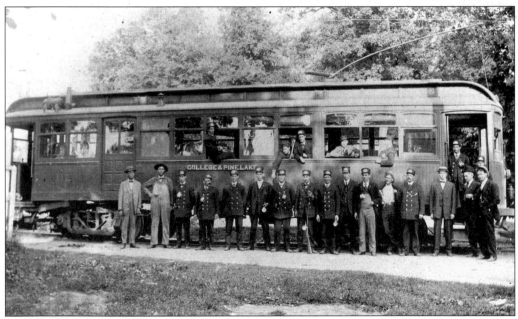

INTERURBAN CONDUCTORS AT PINE LAKE, C. 1910S. The College to Pine Lake segment of the route was extremely popular with East Lansing residents. The lake area provided a variety of recreational opportunities not available in the city. On weekends, the last train returning from the lake was always full. Young men even sat on top of the train. (State of Michigan Archives.)

DELTA APEX WHERE MICHIGAN AND GRAND RIVER AVENUES MEET, C. 1910. The first commercial business district originally started near Harrison Road and Michigan Avenue, but like the early Collegeville housing, this area proved too far away and unpopular. Businesses instead began to develop east of the Delta apex, nearer to Abbott Road and the campus. This view is looking westward toward the apex. The first paved road was laid along Michigan Avenue in 1915. (UAHC.)

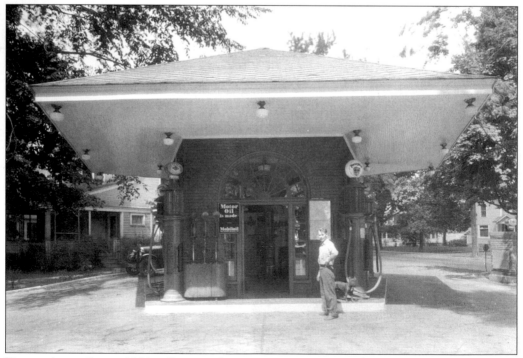

DELTA APEX, LATE 1920s. Because this was an intersection of two major roads, Michigan Avenue and Grand River Avenue, it was a natural place for a gas station. (James Case.)

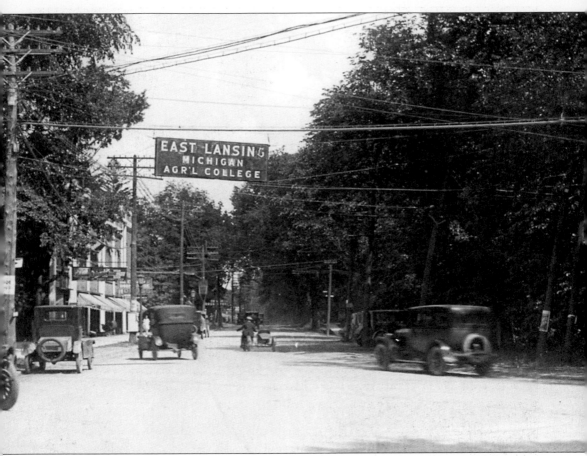

DELTA APEX, C. MID-1920S. This was the view from the apex looking eastward into town. People's Church is directly to the left of East Lansing sign. The College Drug Store sign (near Abbott Road) can barely be seen in the distance. (UAHC.)

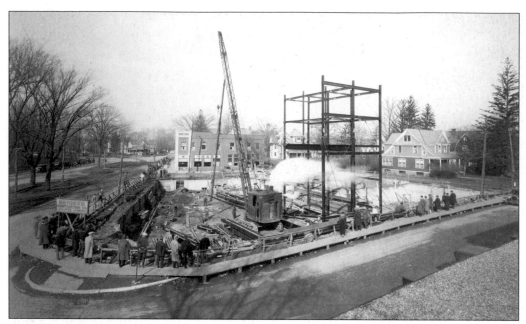

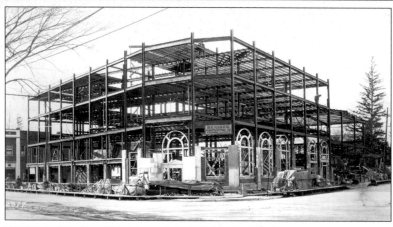

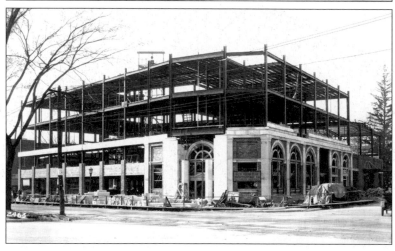

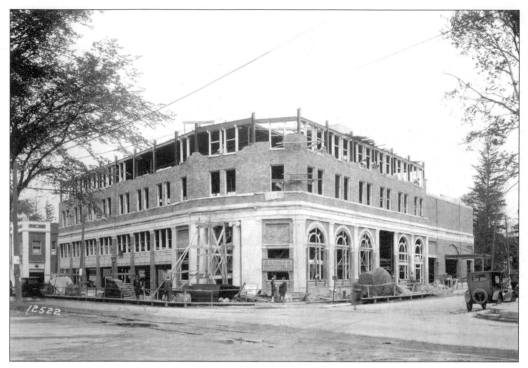

CONSTRUCTION OF THE BANK AND THEATER BLOCK, 1927. The first East Lansing State Bank, established in 1916, was originally built one block to the west, but as the only bank, it expanded in 1927 to suit the needs of the town. This series of construction photos are looking westward from the intersection of Grand River Avenue and Abbott Road. It was East Lansing's largest commercial building. The State Theater was also part of this construction project. (EL.)

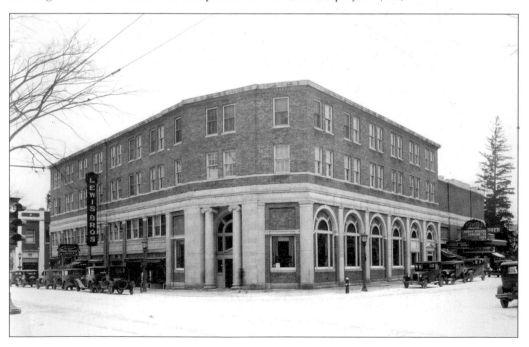

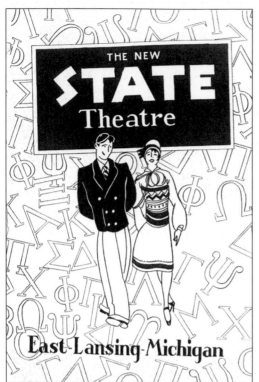

STATE THEATER ADVERTISEMENT, 1928. The State Theater, facing Abbott Road was very controversial when it was built. Residents feared it would be a bad influence on the community's youth. Evidently most had forgotten about the ELMAC which had caused no problems. The State presented vaudeville, plays, and moving pictures for entertainment. It was used by East Lansing and Michigan State College. (UAHC.)

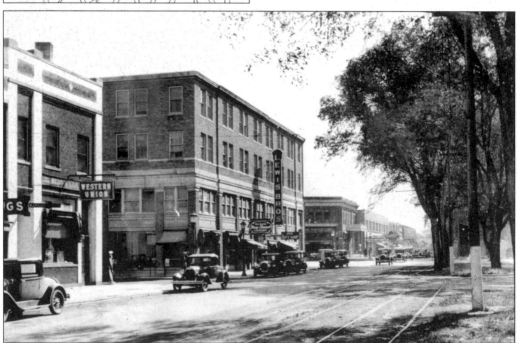

WEST GRAND RIVER AVENUE AND EVERGREEN STREET, LATE 1920S. Continuing eastward from the Delta apex along Grand River Avenue, this is a view of the finished East Lansing State Bank Building. The trolley entrance to campus was across from the Western Union, which was at Evergreen Street. (State of Michigan Archives.)

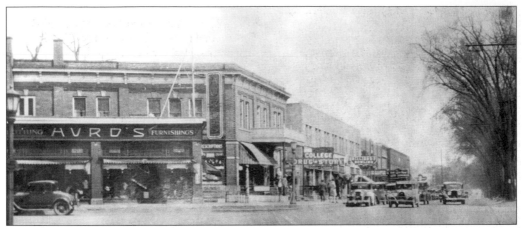

GRAND RIVER AVENUE AND ABBOTT ROAD INTERSECTION, MID-1920S. The Chase Block shows Hurd's and beyond. (East Lansing Historical Society.)

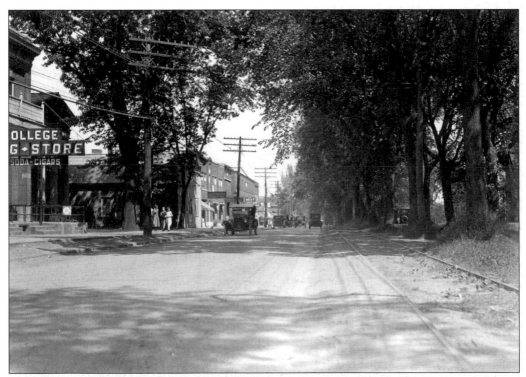

100 BLOCK OF EAST GRAND RIVER, C. EARLY 1920S. The College Drug Store served as a meeting spot for the community, especially the students. The first People's Church and McCune's Garage can be seen just past the drug store. A slow, but definite march toward the development of Grand River Ave. can be seen between this picture and the others shown here. (UAHC.)

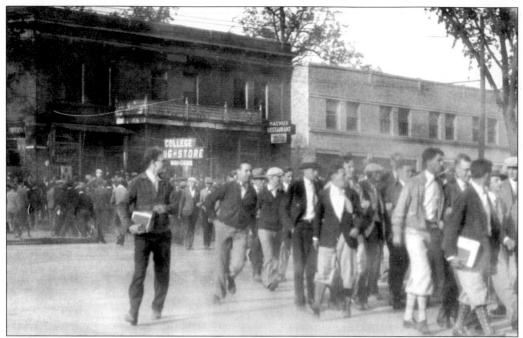

"AFTER THE GAME," 1927. The town celebrates the win of Michigan State College over University of Michigan in a baseball game. The students are crossing over East Grand River from the College Drug Store. This is the same spot as in the previous picture, but now a new building stands where the earlier People's Church had stood. (EL.)

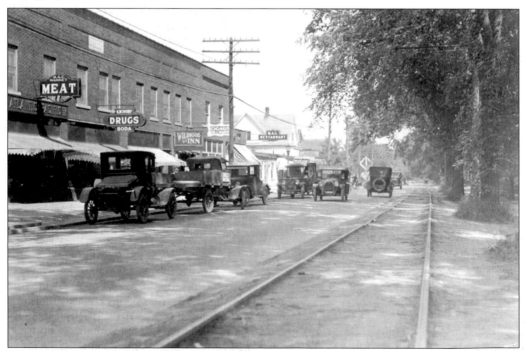

THE OUTSKIRTS OF TOWN, LATE 1920s. Though barely a block east from the College Drug Store, the end of the commercial district is clearly visible in the distance. (UAHC.)

56

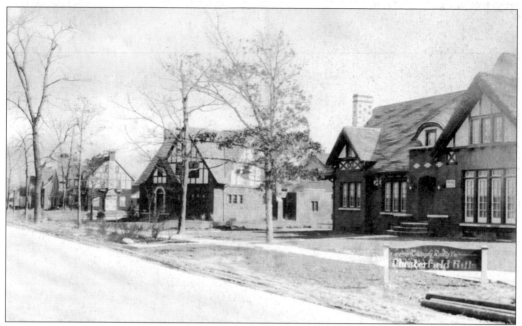

CHESTERFIELD HILLS, 1916. While East Lansing primarily developed to the east towards Abbott Road, those that did not wish to live too close to the activity chose to live just outside the city boundaries. In 1916, Ehinger Realty Company laid out a subdivision northwest of town called Chesterfield Hills No. 1. It was unique because it departed from the idea of rectangular lots and blocks, opting instead to have irregularly-shaped lots and curving streets that followed the natural contours of the area. A short time later, a contiguous section was also developed and called Chesterfield Hills No. 2, and in 1926, Chesterfield Hills No. 3 was developed directly across Grand River Avenue. One of the promotional points about the neighborhood was that no pigs or chickens were allowed. (Mary Fedewa.)

ALTON ROAD, LATE 1920s. The Wales Family owned much of the property along Alton Road, north of Burcham Road. Twenty-three acres on Alton were used for "Victory Gardens" during World War II. The area was later turned into a city park, originally called Alton Park and now called Patriarche Park. John Wales plays near Burcham Road in this picture. (Mr. & Mrs. John Wales.)

57

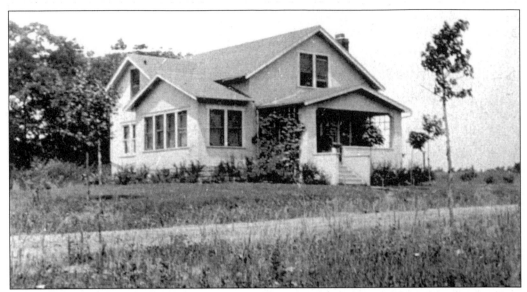

417 ARDSON, 1917. This house, near Harrison Road and Saginaw Street, was the first house in the area. In 1902, this was the site of Lansing County Club's first golf course. In 1919 this area was platted as a new subdivision called Ardson Heights. Today, this house stands in the midst of residential development. (Dave Hadley.)

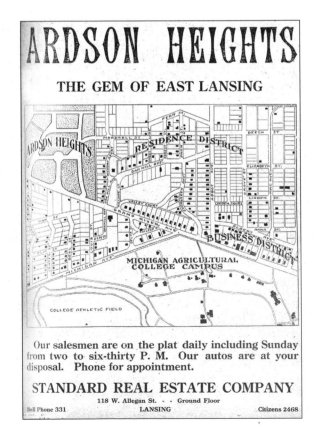

ADVERTISEMENT FOR ARDSON HEIGHTS, 1919.

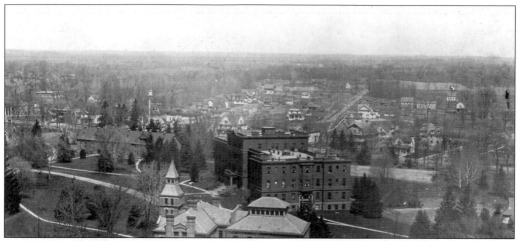

EAST END OF EAST LANSING, C. 1920S. The flat-roofed building is Morrill Hall, which sits along Grand River Avenue. The houses beyond this building show the development eastward from the previous center of development, shown top left. Today, this area is considered the center of the downtown district. (UAHC.)

OFF-CAMPUS STUDENT HOUSING ON ABBOTT ROAD, 1908. Much of East Lansing's early housing was developed for college faculty and staff, but by the time the city was established, student housing was becoming a large problem. Many off-campus society houses, the forerunners to fraternities and sororities, were built in the areas between the business district and the established neighborhoods. (UAHC.)

URBAN FAMILIES, 1930. Although there were still many rural or farming families in the area, the number of families that lived "in-town" grew quite numerous. (Marilyn Ledeburgh.)

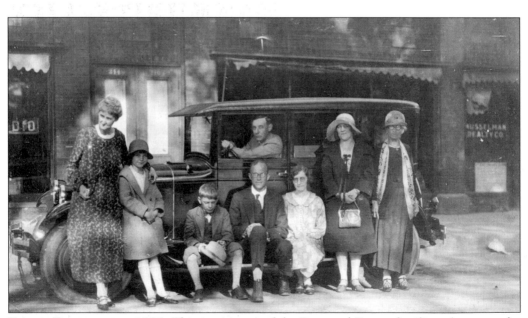

FAMILY PORTRAIT, C. 1925. This is a picture of the Pratt and Brown families taken near the Grand River Avenue intersection. They are between Musselman Realty's first office and the Harvey Photo Shop at 214 Abbott Road in the Chase Block. (Kent Wilcox.)

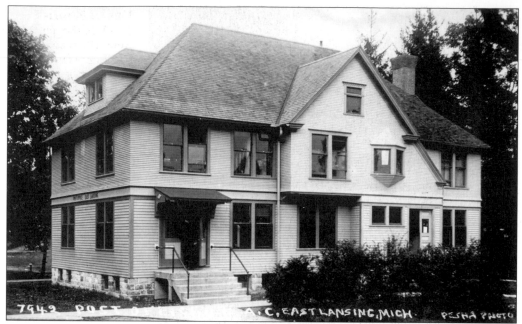

STATION TERRACE POST OFFICE, 1912. Until 1884, when a post office was set up on campus, a student made a trip to Lansing everyday to pick up the local mail. This building, directly across from the trolley's waiting station, was expanded to house the East Lansing Post Office in 1912. The post office remained here until 1923, when it was taken off campus to 211 E. Grand River Avenue. (UAHC.)

COMMUNITY NEWSPAPER, 1919. This was the first city newspaper in East Lansing. Word of mouth was no longer sufficient to communicate all the news of the day to residents. This first issue headlines with the activities of the East Lansing Business Men's Club, which is credited with developing the commercial areas at a rapid rate. (East Lansing Public Library.)

61

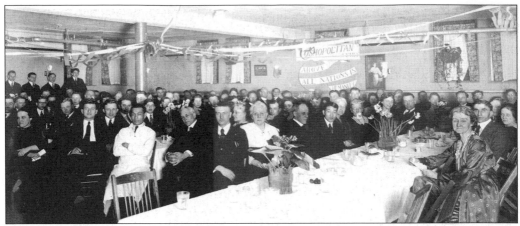

THE COSMOPOLITAN CLUB, LATE 1920S. "Above all Nations is Humanity" was the slogan of this club. The Michigan State College chapter of the Cosmopolitan Club was very active in promoting the ideals of diversity and tolerance throughout the community. This meeting at People's Church indicates its wide appeal. Student members hailed from America, Armenia, Bulgaria, China, India, and Russia to name a few. This club was a forerunner to modern exchange-student programs. (Kent Wilcox.)

OFF-CAMPUS STUDENT HOUSING, 1927. Land that would have been considered quite distant from the campus ten years earlier was now being developed at a quick pace. This stately Hesperian Society house was built as part of the Chesterfield Hill No. 3 subdivision. The Hesperians moved there in 1927 from the Woodbury House, which was in the downtown area. In 1942, this became the chapter house for the Psi Upsilon fraternity. (Mary Fedewa.)

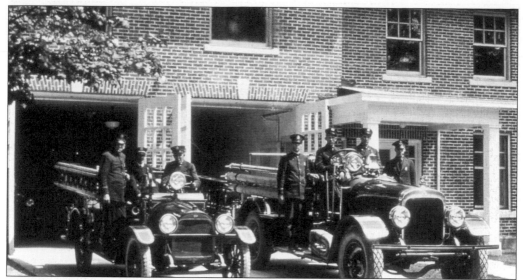

EAST LANSING FIRE DEPARTMENT, C. 1924. East Lansing and the college were plagued by numerous big and destructive fires in their early days. The college bought the first fire engine but shared it, and the water supply, with the city. In 1924, the city built a fire house and bought a second engine. (EL.)

EAST LANSING FIRE VOLUNTEER, 1930s. East Lansing had professional firemen, but it also welcomed volunteers to supplement the staff. Here is one of the two student volunteers who lived in the firehouse at the time. (UAHC.)

EAST LANSING STATE BANK, 1930s. Although the Depression did not hit East Lansing as hard as some other communities, it still caused economic problems. The East Lansing State Bank briefly closed to reorganize itself, locking up city and residents' funds for a short time. The bank survived the Depression and did not have another local competitor until the 1950s. (Dave Thomas, East Lansing Historical Society.)

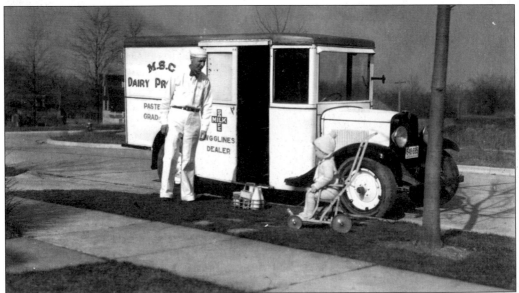

MILK DELIVERY, 1933. Residents who did not have any farmland relied on milk delivery from the dairy cows at the campus. Milkmen also gained business from in-town residents who couldn't or did not want to maintain a "home cow." The milkman delivered milk, cream, butter, and cottage cheese. (UAHC.)

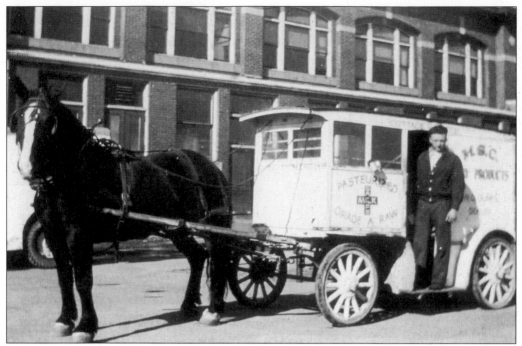

MILK DELIVERY, LATE 1930S. William Keezer became the milkman in the late 1930s. He used a wagon and his horse Don to run a route through East Lansing and part of Lansing. He also delivered beer to parts of Lansing, but the original city charter prohibited alcohol from being sold in East Lansing. (EL.)

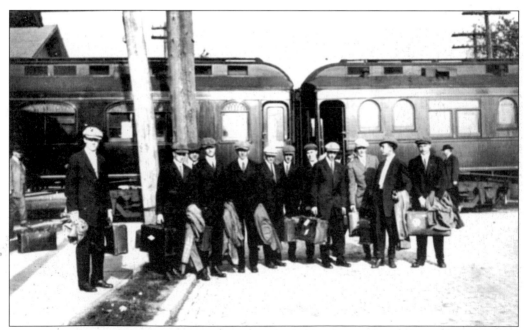

TRAIN TRAVEL, 1930S. The train station at Trowbridge Road, near the southern edge of campus, provided easy access for East Lansing residents and students to travel long distances. This is the MSC baseball team posing for a picture as they leave for an away game. (Dr. Lynn Brumm.)

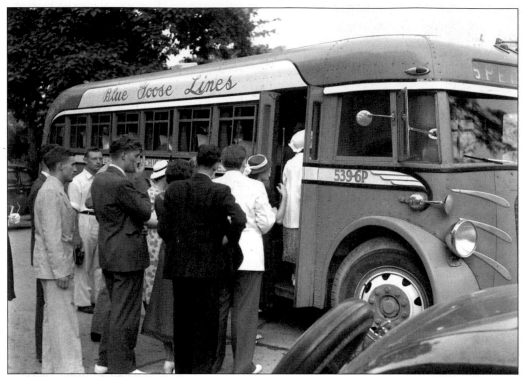

BUS TRAVEL, LATE 1930s. Buses provided a more convenient method of travel to those people who did not own a car or have a rail route near where they were going. The Blue Goose Lines provided service to East Lansing. Here people load up at the bus station on Grand River Avenue between Abbott and Evergreen Streets. (UAHC.)

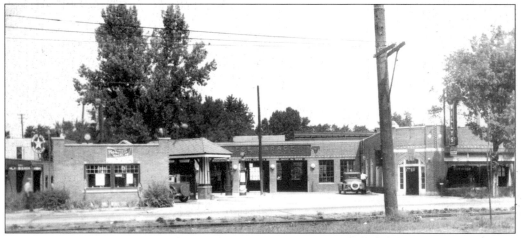

COLLEGE GARAGE, 1930s. The residential nature of the Collegeville area gave way to commercial development by the 1930s. This is the garage at the northeast corner of Michigan Avenue and Harrison Rd that served as a White Star Gasoline station, automobile repair shop, and a Willys dealership. This has been a popular building, serving over the years as a gas station, the public works department, and currently as a restaurant. The building has changed somewhat, but the core garage and garage door openings have remained and are recognizable still, as can be seen in a modern picture of the Garage on the next page.

HARRISON ROADHOUSE RESTAURANT, 2002. (Whitney Miller.)

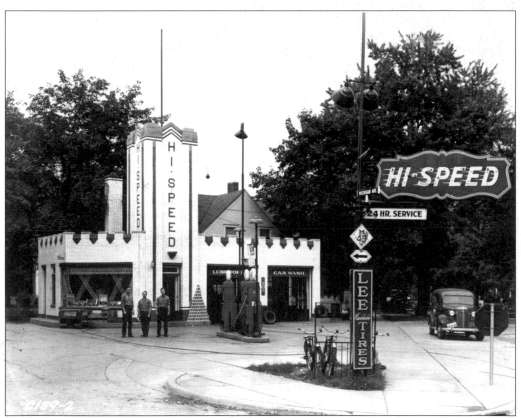

DELTA APEX, C. 1936. The small gas station, existing at this site a few years previously, soon gave way to a larger, more modern Hi-Speed station which offered car washes, refreshments, and 24-Hour service. The pole light on top of the tower and the small globe light on the side of the tower served as an alert that notified the police to return to the station house, a system used before portable radios. (James Case.)

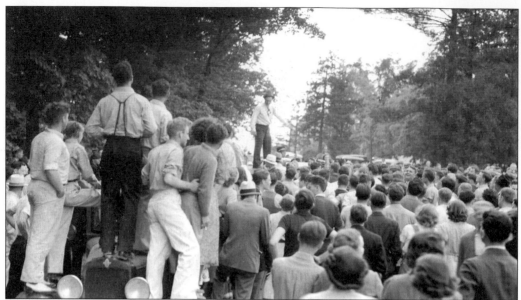

"THE BATTLE FOR EAST LANSING," 1937. The Depression and its associated labor unrest hit Lansing hard because of its numerous automobile factories. Lansing's United Automobile Workers of America insisted that businesses in East Lansing honor the call for strikes. When East Lansing merchants refused to participate, union members called a "Labor Holiday" and marched toward the campus to force the issue. Students and townspeople met the marchers at Michigan Avenue and Louis Street where a fight ensued. The scuffle was resolved soundly by a large number of ROTC students. (UAHC.)

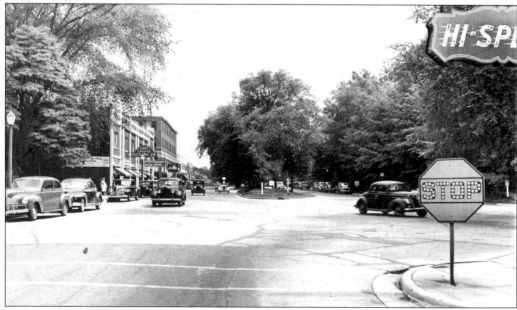

DELTA APEX WHERE MICHIGAN AND GRAND RIVER AVENUES MEET, C. 1940. In this picture looking eastward, the old elm tree border between town and campus can be seen clearly. Grand River Avenue was now a boulevard with elms serving as a shady median. Parking was allowed on the street. (UAHC.)

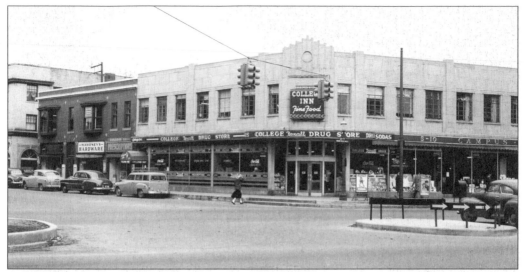

100 BLOCK OF EAST GRAND RIVER, LATE 1940s. The Chase Building housed the first business in the downtown area. Built in 1903, it deteriorated substantially in the succeeding 36 years. T.H. Goodspeed had the wooden building demolished in 1939, and it was replaced by this imposing Art Deco structure. (UAHC.)

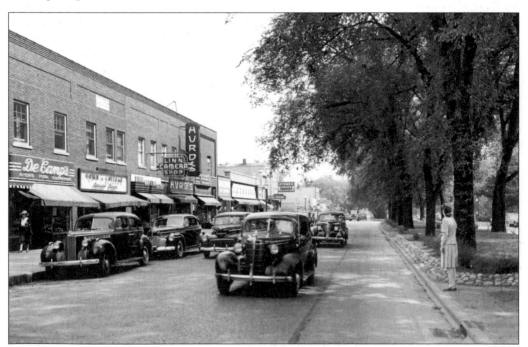

200 BLOCK OF EAST GRAND RIVER AVENUE, C. 1940. Although the Depression initially caused a slowdown in construction, East Lansing recovered quickly, due in part to increased enrollment at the college. Throughout the late 1930s, a construction boom occurred. This boom prompted many businesses to build new stores or remodel the old ones. The dark-brick Hicks building remained and hosted several relocated businesses, while many of the wooden buildings beyond it were replaced with updated structures that included indoor plumbing and modern facades. (UAHC.)

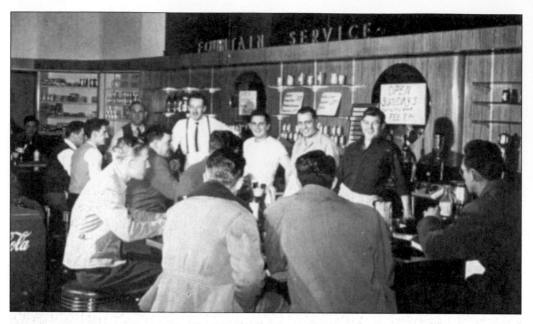

WASHBURN'S SMOKE SHOP. Charles Washburn started his smoke shop in 1916, at first selling just tobacco products, then expanding to offer many products and services. These little ads from 1934 illustrate the variety. The soda fountain, pictured here in 1948, illustrates its popularity and its tradition of "Men Only," which started as a fib teenage boys told their mothers so they would have some place to escape to for fun.

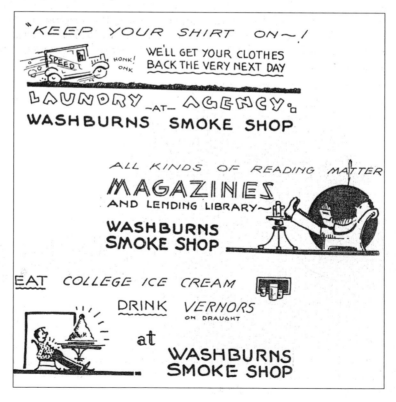

POST OFFICE BUILDING, 2002. East Lansing established delivery/carrier service in 1921, in part because the post office did not have enough room for more post office boxes. Finally, a new post office was built in 1934 at 317 Abbott Road. It was built as part of the federal Public Works Administration (PWA) projects. Its interior mural, showing the reaping of a harvest, was commissioned by the Works Progress Administration (WPA). In 1977, the mural was restored and moved to MSU Main Library. The building has since housed restaurants, a Secretary of State Office, and an art gallery. (Whitney Miller.)

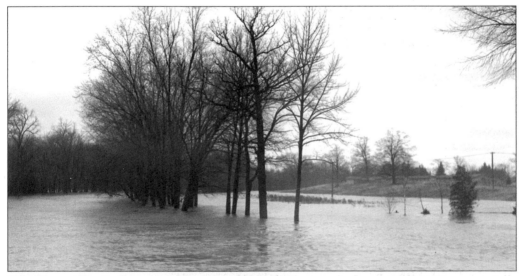

RED CEDAR RIVER FLOOD, 1938. The Red Cedar frequently floods in the spring, especially near the College's athletic fields. The houses seen in the background once stood were the University's Kellogg Center is now. (UAHC.)

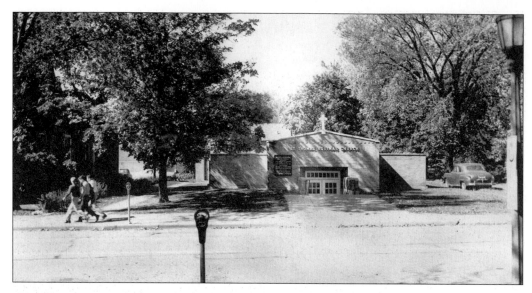

CHURCHES, 1940S. People's Church served the needs of the primarily Protestant community for many decades. As the community grew, so did the diversity of religious needs. Many new churches were established in the 1940s. Construction of St. Thomas Aquinas Church was started on Abbott Road across from City Hall in 1941. An elaborate building was planned, but only the basement was complete before work was halted during World War II. The building was never completed, and later a church and school were built on Alton Road. Martin Luther Chapel and House was also established on Abbott Road in an existing house during this time. (EL, Martin Luther Chapel.)

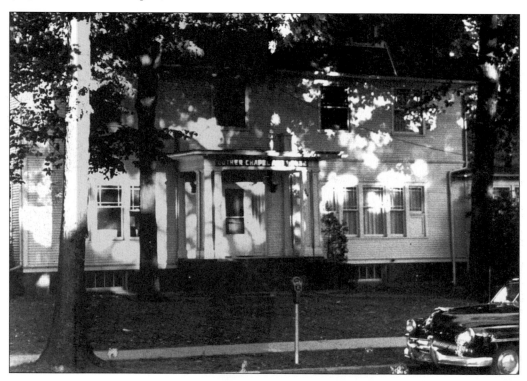

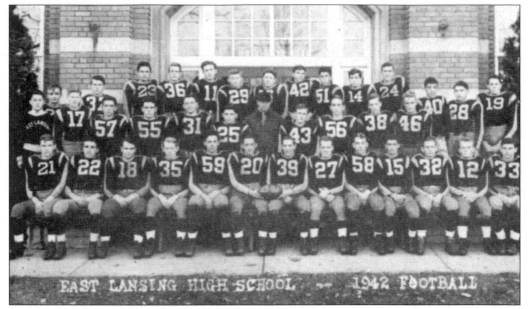

EAST LANSING HIGH SCHOOL FOOTBALL TEAM, 1942. East Lansing Schools have always been dedicated to providing quality extracurricular programs for all their students, especially during the difficult war years. The 1942 Trojan football team gave Coach Shaver his 100th victory in his 18 years as coach of East Lansing. (Marilyn Ledeburgh.)

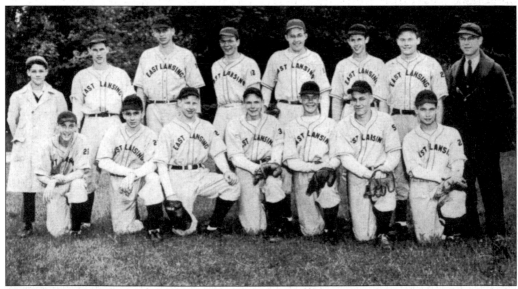

EAST LANSING HIGH SCHOOL BASEBALL TEAM, 1942. Many of the football players also played baseball; even the coach did double duty. Forrest Rienhart, former MSC baseball star, served as baseball coach and band director. (Marilyn Ledeburgh.)

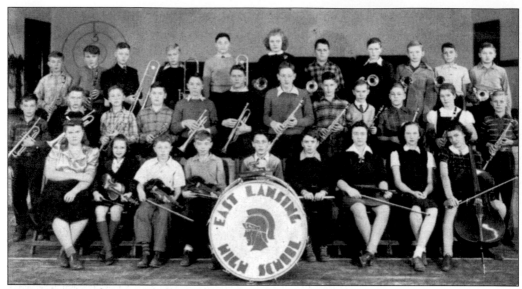

EAST LANSING JUNIOR HIGH SCHOOL ORCHESTRA, 1942. The junior high school students also dedicated themselves to their various pursuits. The 1942 Junior Orchestra presented a Fall Instrumental Concert, a Matinee Musical, and a Spring Concert. (Marilyn Ledeburgh.)

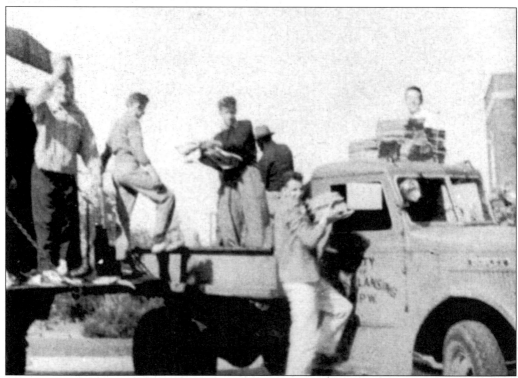

CHARITY WORK, 1944. The annual paper drive was conducted by many of the high school men, who were also eager to pitch in during troubled times. (Marilyn Ledeburgh.)

TRANSPORTATION, 1940S. Bicycling had always been popular in East Lansing and on the campus. Area pictures for the 1890s frequently show bicycling as a leisure activity. However, with wartime gas rationing, bicycling became more of a practical matter. Here faculty members bicycle from their East Lansing homes to campus in 1942. (UAHC.)

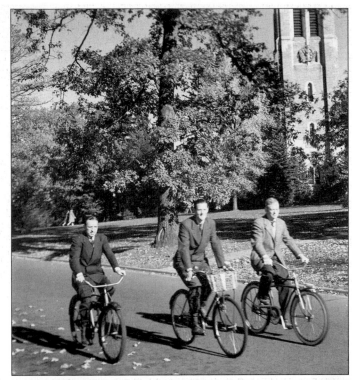

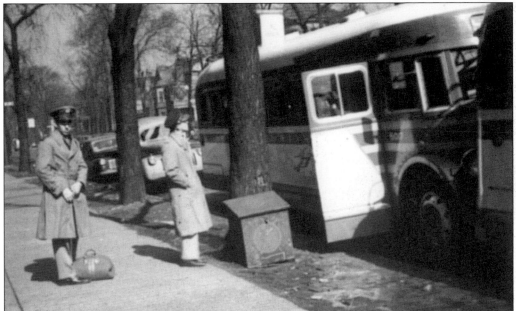

MILITARY SERVICE, 1943. Michigan State University has always had a very strong commitment to supporting our nation's wars. Memorial services for students who served have been conducted since the Civil War. Reserve Officers Training Corps (ROTC) classes were a staple in male student's curriculum through the Korean War, and most were willing to put their studies on hold to serve their country. This is a picture of young men reporting to the buses at the East Lansing draft point. (Frank Beeman.)

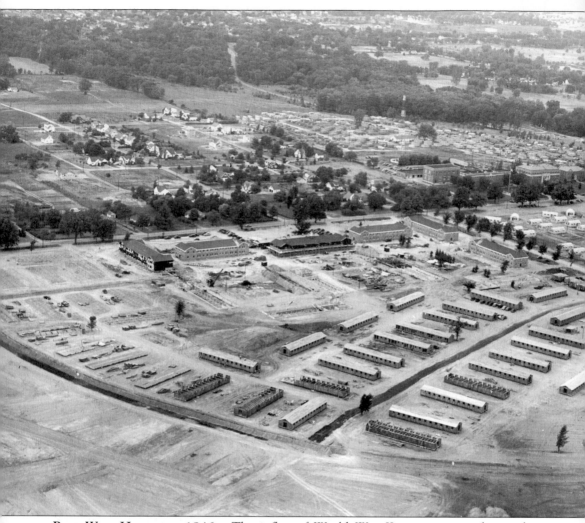

Post-War Housing, 1946. The influx of World War II veterans was the single most important factor in transforming East Lansing from the town it was into the town it is today. Most veterans were able to attend Michigan State College through G.I. Bill funding, and many of these students remained in the area after their schooling was finished. The massive population increase launched several land annexations, forced new housing developments, and caused an irreversible transformation and expansion of the campus. Other than the area shown at the upper left corner and the State Police Building on the right, the entire region pictured here was transformed into buildings to accommodate returning soldiers. (UAHC.)

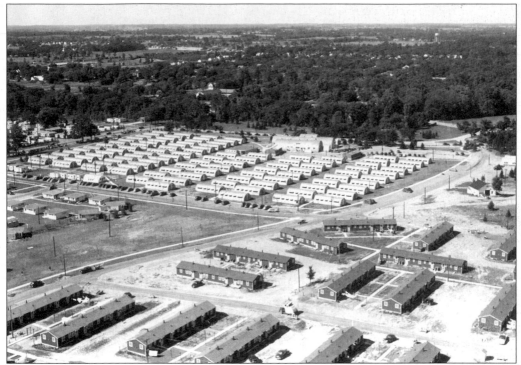

G.I.VILLE, 1947. Temporary structures, apartments, trailers, and the Quonset village were erected for housing, classrooms, and college offices. Some of the quonsets remained through the 1980s, when the land was cleared to construct a new collegiate basketball facility, Breslin Center. (UAHC.)

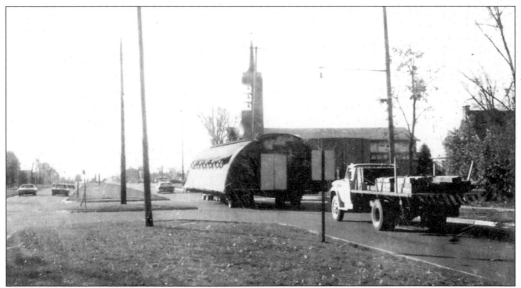

QUONSET BEING MOVED DOWN HARRISON ROAD, 1974. Some of the original quonsets were used on campus through the early 1980s, though most were torn down or bought and moved from campus throughout the 1960s and 1970s. Some can still be seen around Lansing being used for storage and businesses. (Jack Thompson.)

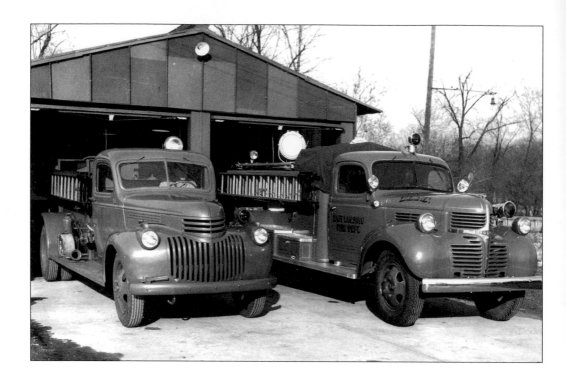

EAST LANSING FIRE STATION FOR THE MSC CAMPUS, 1946. The increased risk of fires in the numerous small, temporary structures that populated the western edge of campus mandated that fire protection be provided from a closer spot than downtown East Lansing. A second fire station was added at the northwest corner of Kalamazoo Street and Harrison Road. In 1965, this new station was built in a main section of campus, but it still remains part of the East Lansing Fire Department. (EL.)

Three

A MODERN TOWN

BUS STOP, C. 1950S. East Lansing was firmly thrust into the modern era in the 1950s. As the population grew, city services, housing, roads, and businesses grew with it. Modernization was the call of the day, as old buildings and old ways were discarded in the name of change and improvement.

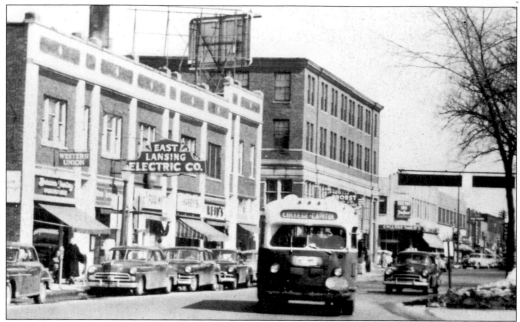

PUBLIC TRANSIT, 1950S. Despite the rise of the automobile, public transportation was well-used. After shutting down the interurban lines in the 1920s, bus lines took their place in the 1930s. Two bus companies battled to capture the lucrative Lansing-East Lansing route; the winner offered 110 departure times a day on the route. (EL.)

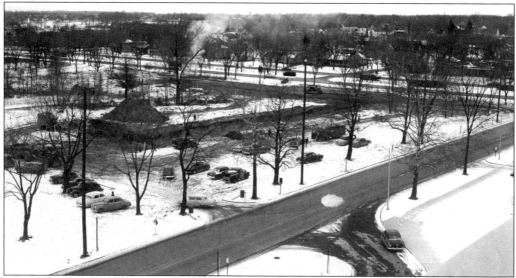

BRODY COMPLEX/CITY DUMP, 1954. Although the temporary structures on the western edge of campus accommodated the influx of new students, it became clear that new permanent structures would have to be built by the college. Brody dormitory complex (with the largest non-military cafeteria in the world) was started in 1954 and completed in 1956 on land that had previously been used as the East Lansing city dump. It is also interesting to note that the western edge of Brody sits across from the site of the 1891 Bradford Cottage, which was once considered very far from campus. (EL.)

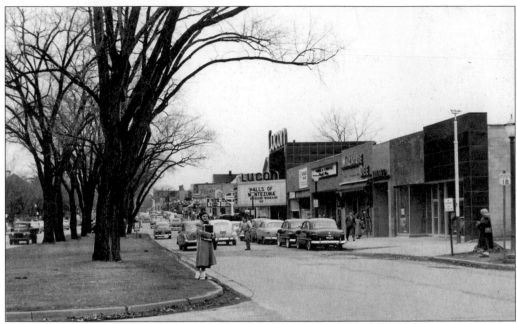

LUCON THEATER/GRAND RIVER, 1950. East Lansing's business district also grew dramatically to accommodate the rise of the local population. A second movie theater, the Lucon, was added; its name was later changed to the Campus. Grand River Avenue was still a major highway from Detroit to Lansing, and the increased foot and automobile traffic around this section made a dangerous pathway. To help alleviate the traffic problems, the State Highway Department banned parking along the street, prompting East Lansing to begin their enduring need to provide parking for the downtown business district. (UAHC.)

EWING HOUSE, 1953. Parking lots weren't the only necessary improvement; road extensions and expansions were also needed. The Ewing House was considered a landmark home even in 1953. It was the first home in the Oakwood subdivision that was platted east of the Delta area. Nevertheless, it was torn down to extend Albert Street to Evergreen Street and to make way for a parking lot. (*Lansing State Journal.*)

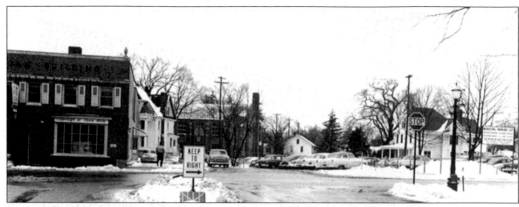

CITY PARKING LOT, 1955. This parking lot was Municipal Parking Lot No. 1, constructed between the post office and the Savings and Loan Association Building at Abbott and Albert Streets looking west. This picture shows the extension of Albert Street once the Ewing House was destroyed. The big building in the background is the rear of People's Church. (EL.)

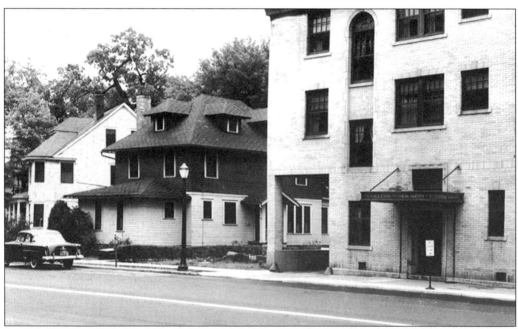

FUTURE CITY PARKING LOT, 1955. The stores along Grand River Avenue had a narrow alley that ran behind them for trash disposal and delivery vehicles. When parking along Grand River was eliminated, parking and store access were provided from the rear side. A whole block of houses was eventually eliminated to provide Municipal Parking Lot No. 2. This is a picture of the houses that used to be behind the College Manor. A modern view of same area is provided in the next picture. (EL.)

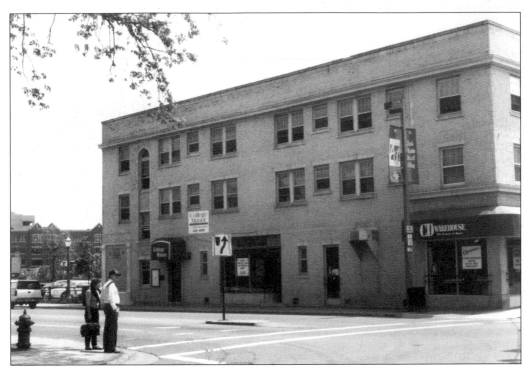

COLLEGE MANOR AND PARKING LOT, 2002. (Whitney Miller.)

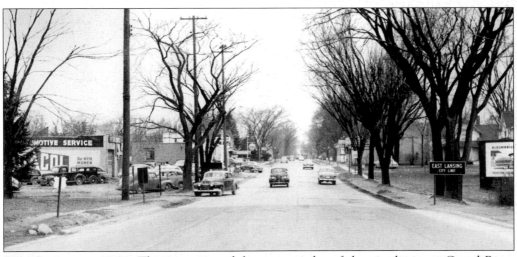

CITY LIMITS, C. 1950. This is a view of the eastern edge of the city limits at Grand River Avenue and Woodmere Street, around 1950, looking west. This is the same boundary line that the city originally had in 1907, and houses were built toward this border (and beyond) over time. However, by 1950 it was also evident that commercialization was becoming prevalent along Grand River Avenue, east of the downtown business core. (EL.)

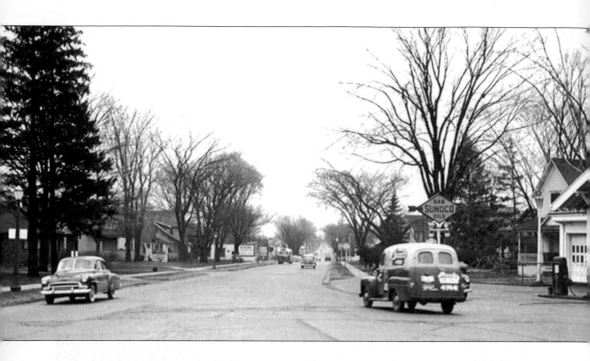

ROAD WIDENING, RESURFACING, AND CHANNELIZATION, 1951–1952. These pictures look east from Grand River Avenue and Bogue Street, before and after construction to modernize the passage. The new, modern look was achieved by removing trees, updating signs, updating streetlights, adding medians, and widening and resurfacing the road. The stark contrast between the tree-lined downtown and this newly created east end remains today. (EL.)

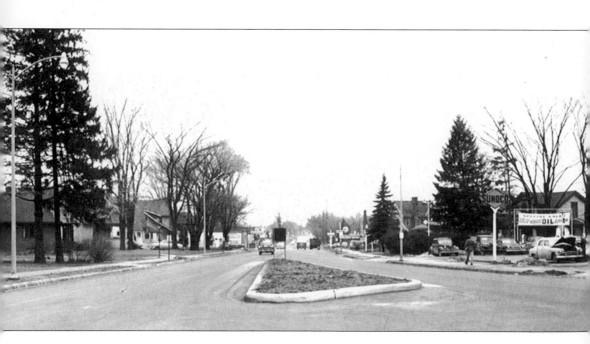

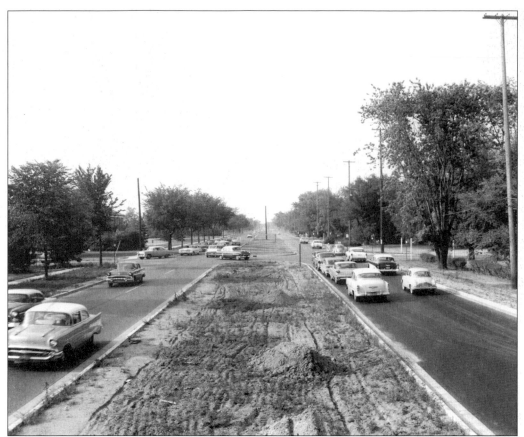

HARRISON ROAD, 1959. East Grand River Avenue was not the only area to be modernized. By the end of the 1950s, many roads and sections of town had been improved and modernized to accommodate the area's growth. This is a picture of Harrison Road at Shaw Lane looking south. (UAHC.)

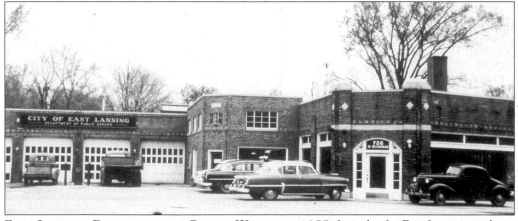

EAST LANSING DEPARTMENT OF PUBLIC WORKS, c. 1955. In order for East Lansing to keep up the new roads and with increased demands placed on city services, the Public Works Department expanded into the old College Garage building. (EL.)

CLEARING SNOW, 1956. Public Works employees clear the snow from behind People's Church and the Valley Court area. Note the lack of commercial development in the area. (EL.)

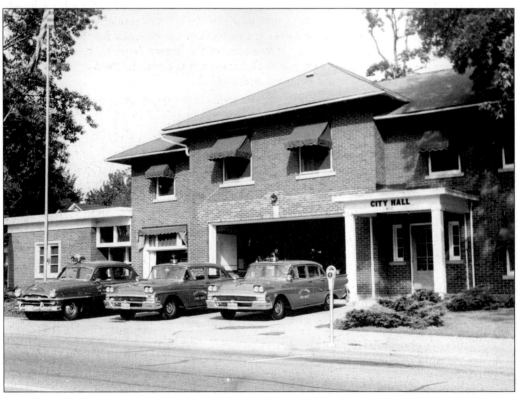

CITY HALL EXPANSION, C. 1955. This building expanded in 1952 to accommodate City Hall, the Police Department, the Fire Department, and the Library. (EL.)

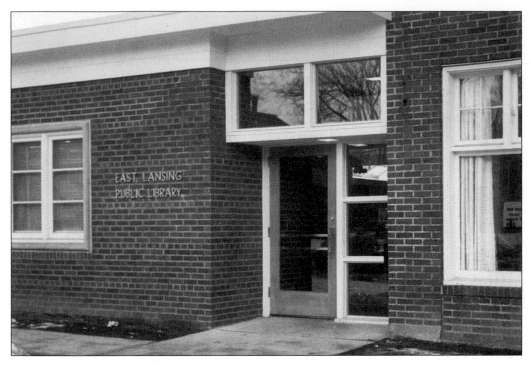

LIBRARY IN CITY HALL, C. 1955. East Lansing's first library was housed in People's Church using books loaned from the State of Michigan Library in 1923. Town residents used the library extensively and donated items to create and expand a permanent collection for the city. Private funds and soon city funds were appropriated to maintain the library. In 1931, it was clear that the library needed to move to a larger place. A location was found in the City's Municipal Building, and in 1952, this space was enlarged again. (EL.)

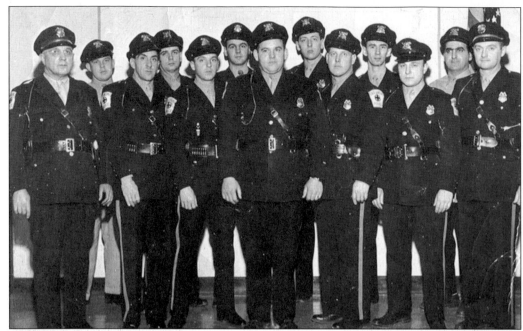

EAST LANSING POLICE DEPARTMENT, 1950. The East Lansing Police Department was officially formed in 1921. They had between one and four officers through World War II. Charlie Pegg took over as Police Chief in 1946 and greatly expanded the department. By 1950, there were thirteen on staff. He also adopted the first logo shown on the sleeve of the officers. It showed a green cross, representing safety, laid upon a red wheel, representing traffic. (East Lansing Police Department—ELPD.)

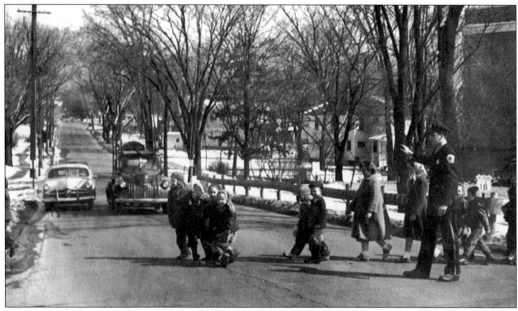

SCHOOL CROSSING, EARLY 1950s. Officer Bill Sharpe fulfills crossing guard duty in front of Central School on Grand River Avenue. Protecting children from the traffic on busy city streets had always been one of the department mandates, as noted in the logs from 1921. (ELPD.)

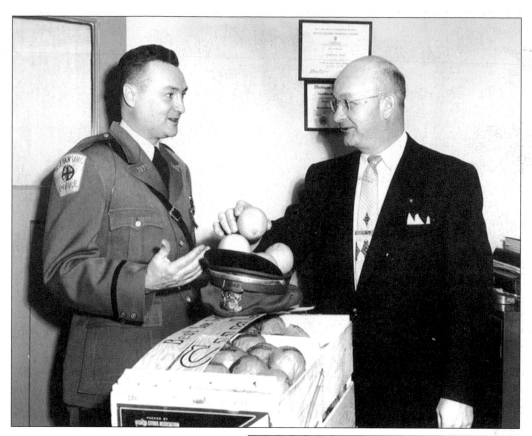

THE CHIEF & MAYOR, LATE 1950S.
Police Chief Charlie Pegg and City
Mayor Max Strother pose for a publicity
shot promoting an unknown fundraiser
involving Florida oranges. (ELPD.)

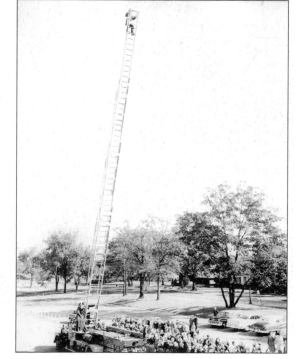

**FIRE DEPARTMENT VISIT SCHOOLS,
LATE 1950S.** The East Lansing Fire
Department was very active in
promoting fire safety in the schools.
Here a fireman invites a child to join
him at the top of the aerial ladder
during a visit to Glencairn School. (EL.)

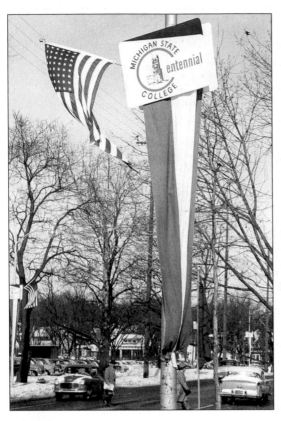

CENTENNIAL CELEBRATION, 1955. The college, now called Michigan State University, celebrated its 100th anniversary in 1955. The celebration entailed many events involving the entire community. This picture shows the banners along city streets in honor of the anniversary. Flags were also hung on every lamp post. This had been a tradition for awhile. Flags were typically hung for home football games, sometimes all the way to the Capitol. (UAHC.)

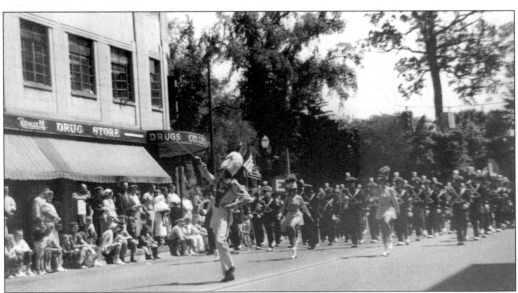

EAST LANSING'S GOLDEN ANNIVERSARY PARADE, 1957. East Lansing's biggest celebration occurred in the spring of 1957 for the 50th anniversary of becoming a city. A large parade traveled west on Grand River Avenue and turned up Abbott Road. The East Lansing High School performed "Forward March" led by Drum Major Lou Potter. (Louis Potter, East Lansing Historical Society.)

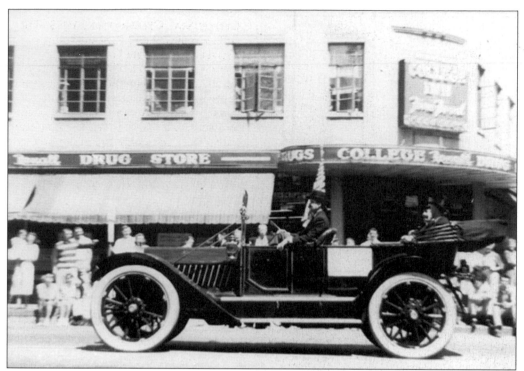

ROOSEVELT REENACTMENT, 1957. A 1907 Oldsmobile carrying "Teddy Roosevelt," travels the parade route. This was a tribute to the famous 1907 tour by Roosevelt to East Lansing for the MSC's 50th anniversary. (Louis Potter, East Lansing Historical Society.)

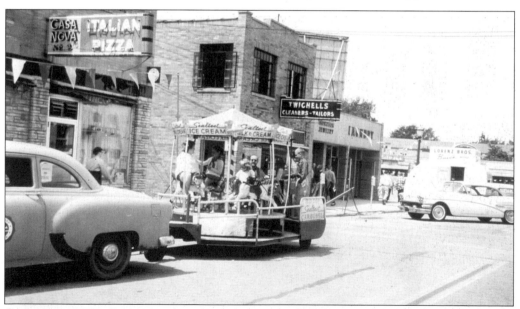

CARNIVAL, 1958. Downtown has always been a good place to host community events. Little carousels like this visited often, advertising ice cream or Vernor's soda pop. This picture was taken on M.A.C. in front of Twichells Dry Cleaners, which as been at the same location since the late 1920s. It remains East Lansing's oldest operating business. (EL.)

ALTON PARK, 1950s. Downtown was not the only place for area residents to enjoy events. Alton Park served as the location for a variety of events including musical concerts and the traditional Kiwanis Club's Annual Barbecue Picnic. (EL.)

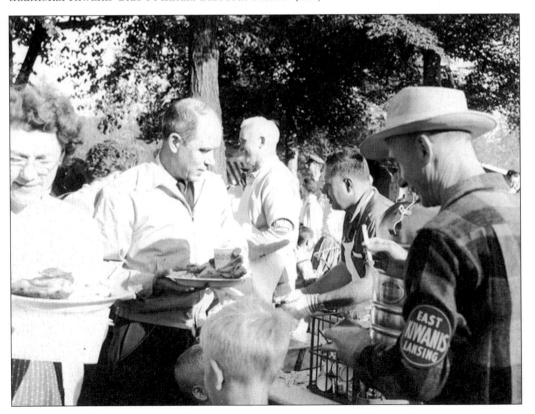

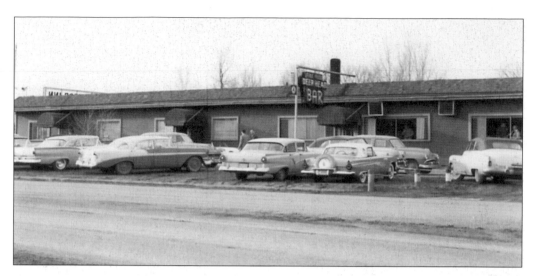

LIBATIONS, 1950S. According to the original city charter, the sale or purchase of liquor by the bottle or by the glass was prohibited. The vast majority of the town's residents strongly supported this regulation. However, this did not stop people from crossing over the city borders to partake in libations. Two popular locations were the Deer Head Bar, at the corner of Hagadorn and Haslett Roads (where a gas station now stands), and Coral Gables, which was closer to the campus on Grand River Avenue. The original Coral Gables burned in 1957. In 1958, East Lansing expanded its borders encompassing the old location, forcing the new business to move over the city line to its current address. (EL.)

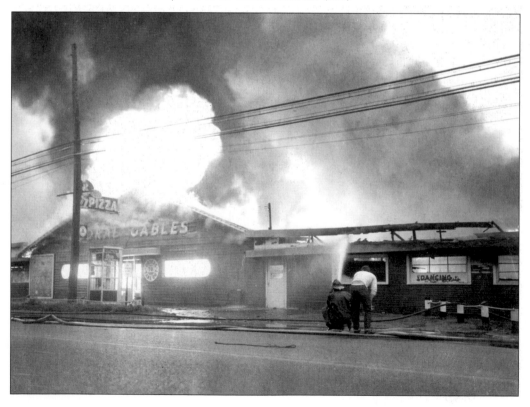

BIGELOW-KUHN-THOMAS HOUSE, 1950S. This house was built in 1849 by Horace Bigelow, a local farmer. It is located across the street from Marble School. When East Lansing expanded it borders in 1958, this house became the oldest privately-owned home that is still used as a residence in East Lansing. It is on the list of Michigan Historic Sites. (Dave Thomas.)

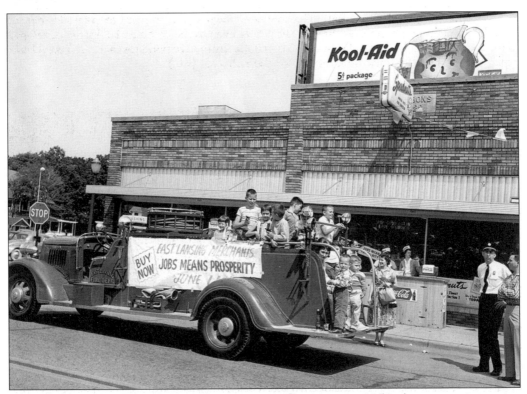

EAST LANSING FIRE DEPARTMENT SUPPORTS THE COMMUNITY, 1958. As a promotion urging people to patronize downtown businesses, this fire engine sits outside Spudnuts Bakery on M.A.C. Avenue. Fire Chief Arthur Patriarche looks on as children play on the truck. (EL.)

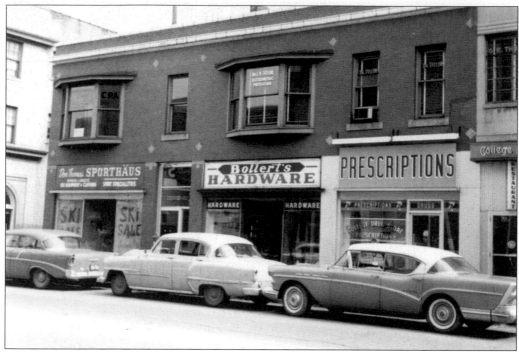

DOWNTOWN EAST LANSING, 1959. The core downtown area continued to maintain some of its early buildings and businesses through the 1950s, even as the commercial district developed to the east and west. Bollert's Hardware occupied the distinctive building that stood on Abbott Road. In the early 1900s the building housed the ELMAC. (EL.)

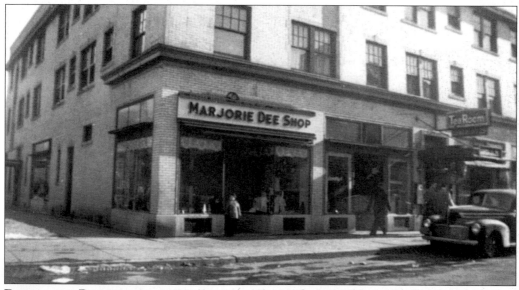

DOWNTOWN RELOCATION, 1950s. Many businesses also moved from one location to another within the downtown area. The Marjorie Dee Shop started out in the College Manor on Abbott Rd and later moved to a better spot on Grand River Avenue. (Marjorie Ritchie.)

MORE RELOCATION, 1950s. Some businesses moved out of the downtown area altogether. The bus station, which had been located on M.A.C. Avenue, moved to a less congested location near Central School. (EL.)

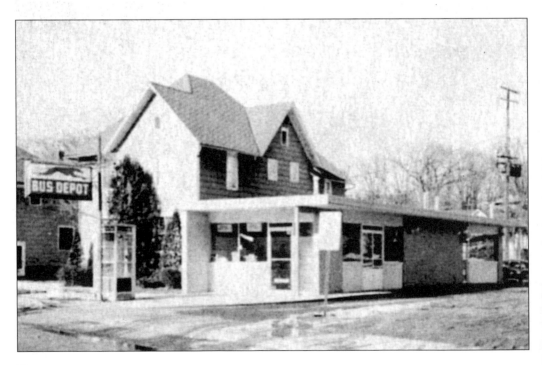

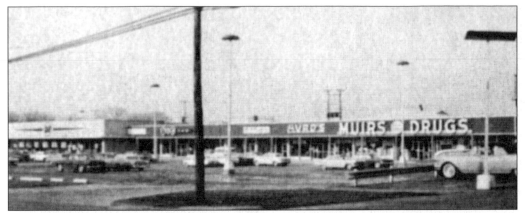

BROOKFIELD PLAZA, 1959. New shopping centers with spacious parking lots became popular around this time. Hurd's, which was one of the early businesses in the Chase Block, had moved to several locations along Grand River Avenue, and moved again to the newly developed Brookfield Plaza at Hagadorn Road.

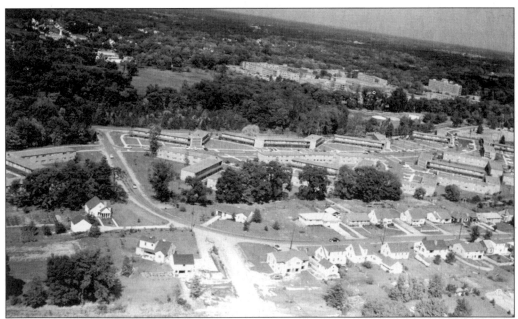

FLOWER-POT AREA, 1956. The farmland south of Michigan Avenue and west of Harrison Road had been developed steadily since the 1920s. The Michigan Mounted Police (later the State Police) organized in 1919 and bought part of the property for training and barracks. The college bought part of it for housing, and the city used part of it for city services. A large section was also subdivided for housing. The number of houses built there grew rapidly in the 1940s and 1950s. The area was officially called Lilac Lawn Farm, but it became known as the flower-pot area because the streets were named after flowers. This aerial picture looks north, and the Brody Complex is at the very top. (UAHC.)

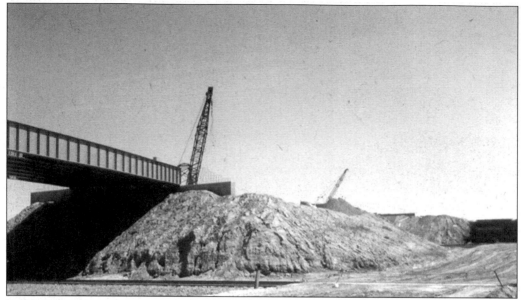

I-496 Construction, 1963. Behind the Flower-Pot area to the west and south, the State of Michigan built an Interstate that would connect to East Lansing via Trowbridge Road. This is a picture of the construction of the I-496 that runs over the Chesapeake and Ohio line at the end of Trowbridge Road. (Jack Thompson.)

Trowbridge Road Area, 1963. The Trowbridge area was also developing commercially. Trowbridge continued to be the link to passenger and freight trains, but in 1962, a shopping center was built across from the tracks. The recently built interstate would greatly increase traffic along this corridor. (UAHC.)

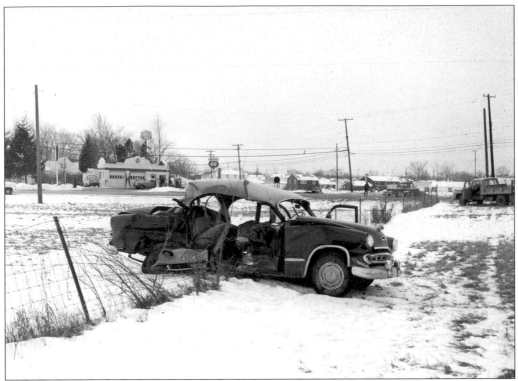

TRAFFIC ACCIDENTS, 1963. While drivers tended to obey the speed limits downtown, they often exceeded the speed limit on the quieter roads at the town's edges. One of the most dangerous intersections in East Lansing was at Hagadorn Road and M-78 (Saginaw Street). Serious wrecks occurred here until the intersection was completely redesigned in the late 1980s. (EL.)

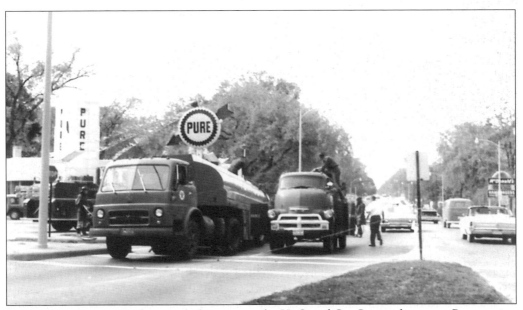

DELTA APEX, 1963. Back towards downtown, the Hi-Speed Gas Station became a Pure station by 1963. Also note the width of Grand River Avenue.

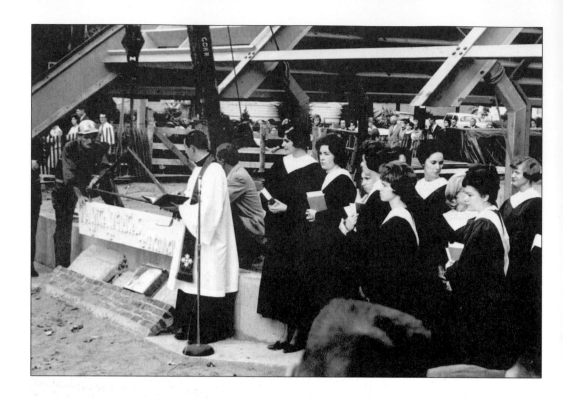

MARTIN LUTHER CHAPEL, 1963 AND 2001. In preparation for enlarging their ministry, the Chapel was expanded in 1963. A full service was conducted on the lawn of the new construction site as the cornerstone was laid. The ministry has been particularly active in reaching out to the international community. The picture below shows the Chapel as it stands after a 2001 addition. (Martin Luther Chapel.)

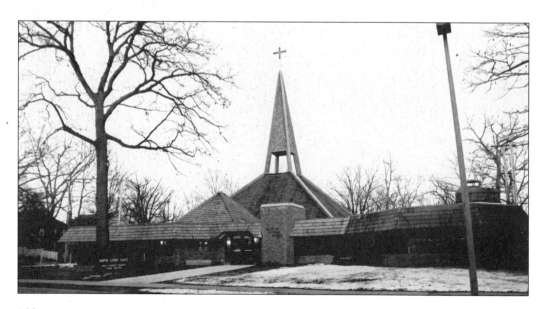

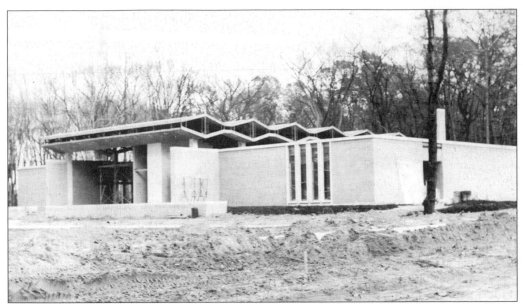

NEW LIBRARY, 1963. Further up Abbott Road, a new city library was built on the edge of Burcham Woods and dedicated on April 21, 1963. As the community continued to support the library, an additional wing was added in 1975, and a renovation took place in 1997. (EL.)

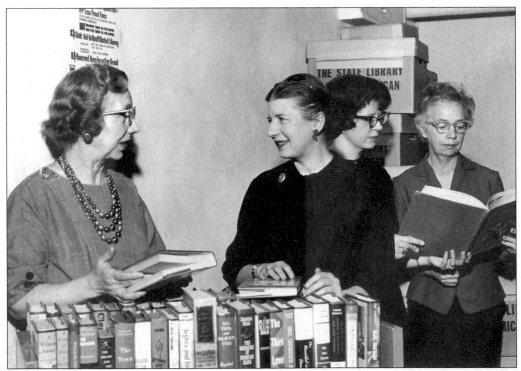

EMERGENCY BOOK LOAN, 1963. Townspeople soon realized that there were not enough books to fill the new library. Once again, the State of Michigan Library loaned East Lansing 2,500 books while the community rallied to raise $1600 for the purchase of new books. In the foreground of the picture is Gertrude Hale, librarian in East Lansing from 1945 to 1965. (EL.)

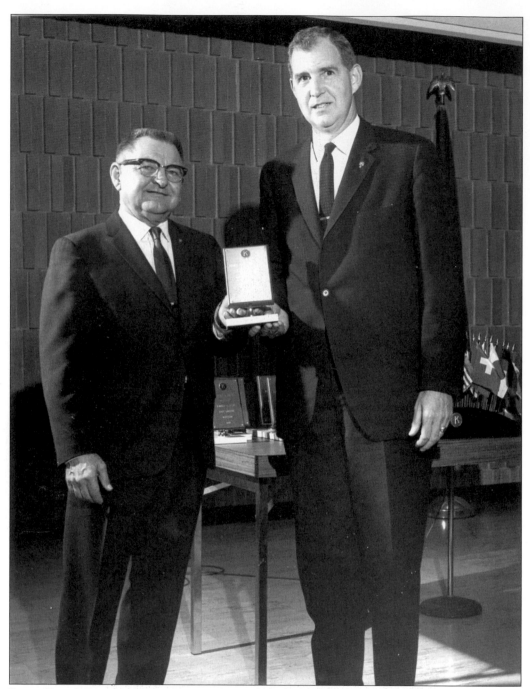

JOHN (JACK) PATRIARCHE, 1967. Jack Patriarche moved to East Lansing in 1922, graduated from MSC in 1938, and has worked most of his adult life for the City of East Lansing. He made significant contributions to the community as the superintendent of public works and city engineer. However, he is most often credited with ushering in the modern era by taking over as City Manager after World War II. He also served as president of the Kiwanis Club of East Lansing in 1954. In this picture, he is honored with the President's Plaque for his service to the Club and the City. The presenter is Earl Richardson, the 1967 president. (UAHC.)

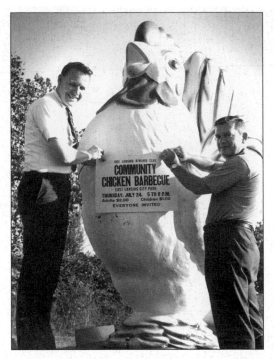

THE KIWANIS CLUB BARBECUE, LATE 1960S. One of the most popular events in East Lansing is the annual Kiwanis Barbeque. Used as a fund-raiser for community projects, the Barbeque was initially held in the 1950s and continues today. It is a huge event that has been coordinated to perfection over the years. The large cooking pits ensure that hundreds of people can enjoy the event. (UAHC.)

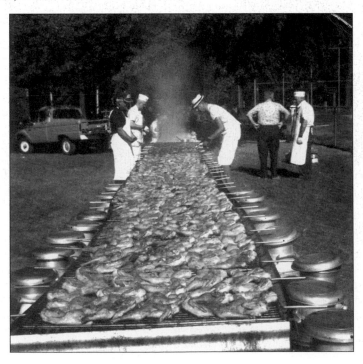

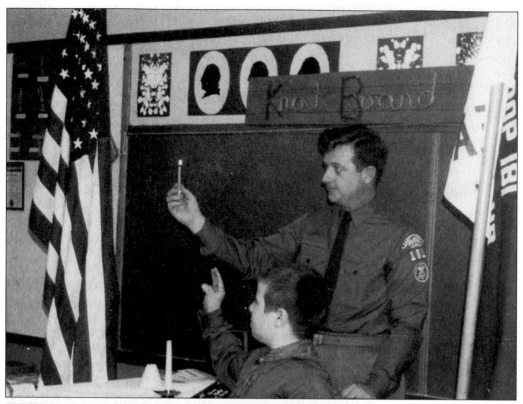

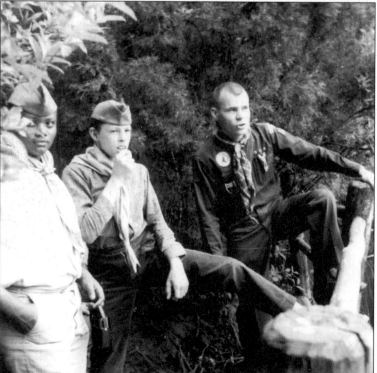

BOY SCOUTS, LATE 1960. The Boy Scouts have been part of East Lansing since the city was first chartered, providing training in leadership and traditional scouting activities for the City's young men. These pictures represent the troop sponsored by the Kiwanis Club. (UAHC.)

OFF-CAMPUS HOUSING, 1965. In the early 1960s, the city changed its zoning codes to allow more apartment buildings to be constructed. Over 2,500 new apartment units were built between 1963 and 1967. (EL.)

COLLEGE PRANKS, 1963. One of the common pranks that fraternities and sororities would play on each other was to "TP" their rival's house, involving stringing toilet paper throughout the exterior of the property. While this was all in fun, some permanent East Lansing residents found this and other such activities annoying and disruptive. Within a few years, much of the previous harmony between students and residents would disappear. This was particularly the case once the city charter was changed to allow alcohol sales.

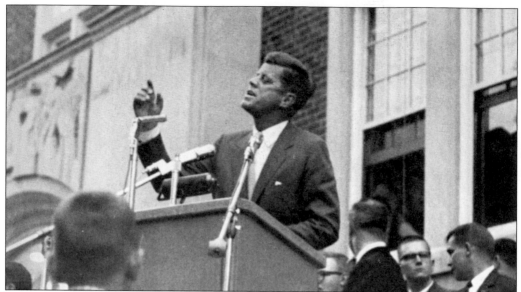

Senator John F. Kennedy, 1960. Kennedy visited East Lansing in October 1960, as he rallied for last-minute support in the upcoming presidential election. Here he speaks in front of the Union Building on campus. (UAHC.)

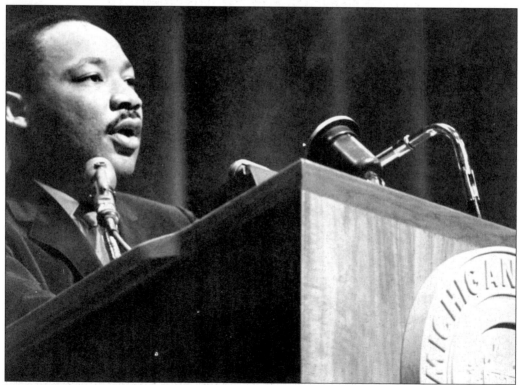

Martin Luther King Jr., 1965. King visited East Lansing in February 1965 to speak about civil rights and to kick off a fund-raising drive for Michigan's Freedom Riders, who would later visit Mississippi. (UAHC.)

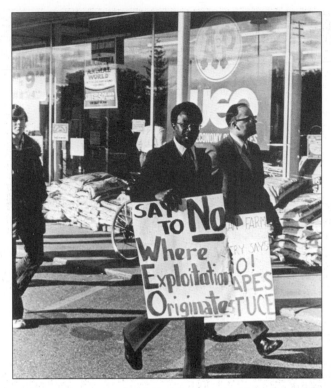

STUDENT DEMONSTRATION, 1974. Local students demonstrated over various social issues during this time. This is a picket line moving along Grand River Avenue heading toward the A&P grocery store at Brookfield Plaza. They were supporting the California United Farm Worker's Grape Boycott led by Cesar Chavez, who later came to East Lansing himself to lead a rally.

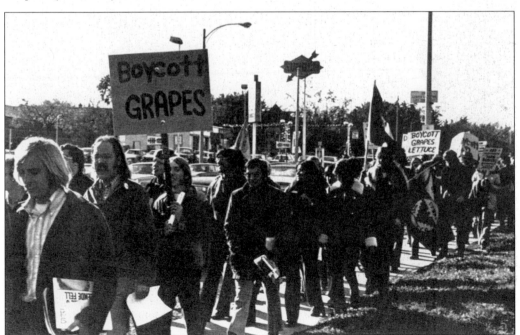

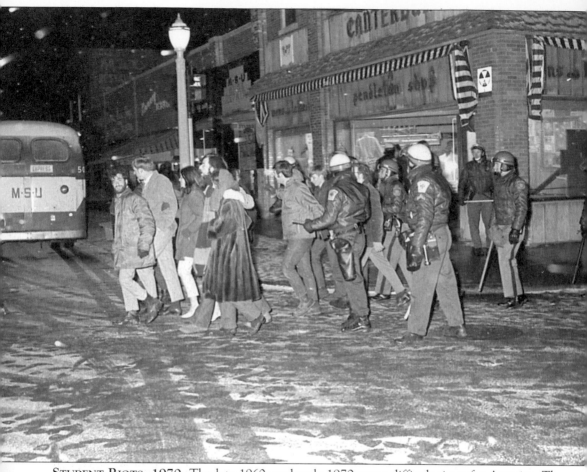

Student Riots, 1970. The late 1960s and early 1970s were difficult times for America. The rift between generations was particularly evident in college towns, and East Lansing was no different. There had been demonstrations by various groups such as the Students for Democratic Society (SDS) and NAACP for several years, but in early 1970 the demonstrations turned into riots. Students were generally upset about the war in Vietnam, but the incident at Kent State and the outcome of the Chicago Eight trial brought conditions to a breaking point. These pictures show the East Lansing Police in riot gear clearing the streets after midnight. The reference to "Bobby" on the boarded-up windows refers to Bobby Seale, one of the Chicago Eight. (UAHC.)

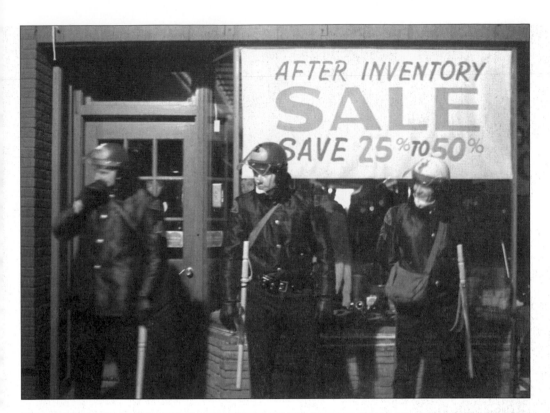

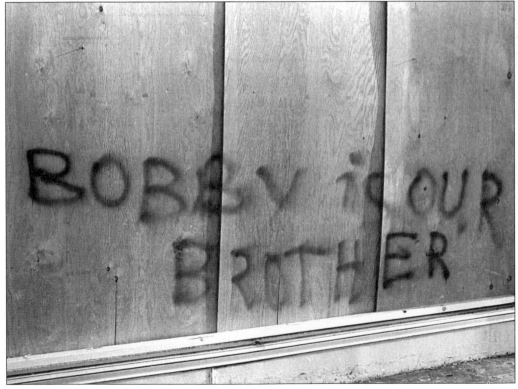

REGISTERING TO VOTE, 1971. A positive side to the unrest in East Lansing was that it prompted people, especially students, to be more politically aware and active. Students made the special trip to travel off-campus and stand in long lines as shown opposite. In 1972 election reforms gave 18-year-olds the right to vote. (UAHC.)

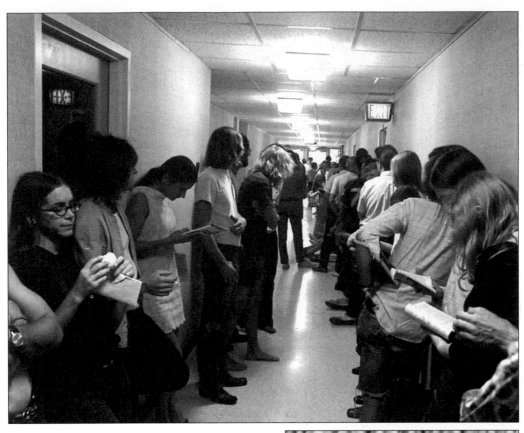

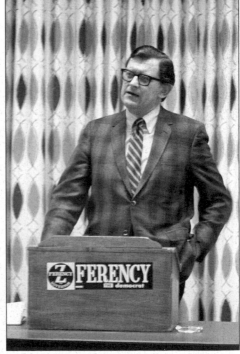

ZOLTON FERENCY, 1970. In addition to the important national concerns of the day, voters also had local concerns. Zolton Ferency, a criminal justice professor at MSU, was politically active most of his life, speaking out about issues, campaigning, and holding office. Though he was defeated five times in his bid for governor, he was deeply concerned about social and political issues, making him a very respected community member. (UAHC.)

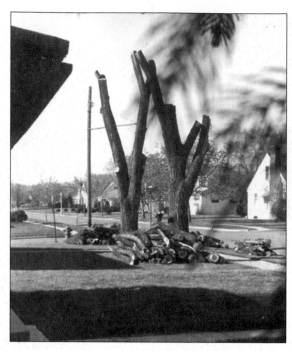

DUTCH ELM DISEASE, 1970. One of the biggest tragedies that befell the city was the onset of Dutch elm disease. East Lansing had always thought of itself as the city within the trees. Dutch elm disease started to make its way into East Lansing as early as 1960, but the agricultural scientists at MSU had held its spread at bay. By 1970, thousands of trees were destroyed, including the iconic elms on Grand River Avenue. (Jack Thompson.)

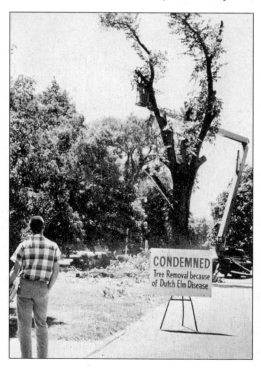

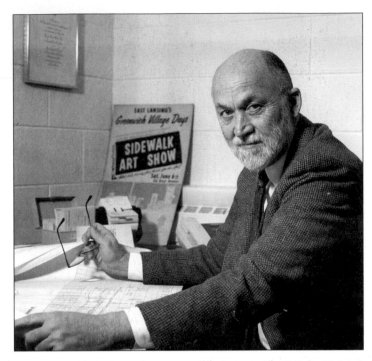

EAST LANSING ART FESTIVAL, LATE 1970S. The Greenwich Village Days: A Sidewalk Art Festival was started in 1963 by Mike Bidwell, and this very popular summer festival continues today. The event evolved into a festival showcasing multiple art forms, including live performances. This dance on M.A.C. Avenue is just one of many activities held downtown during the festival. (East Lansing Historical Society.)

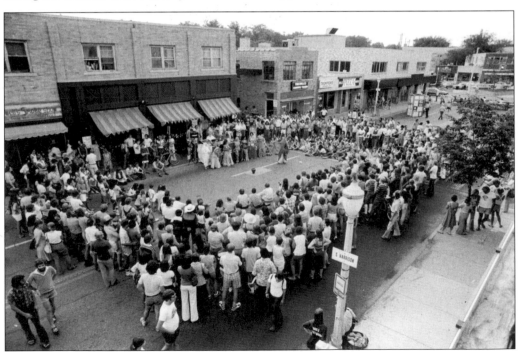

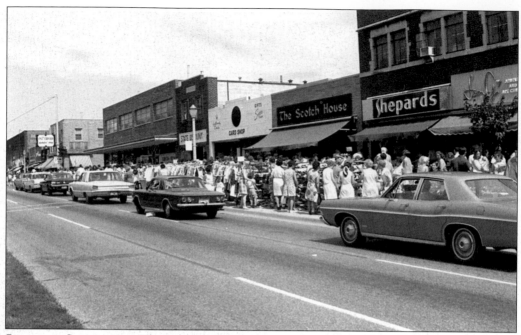

SIDEWALK SALE, 1970. The sidewalk sale began as a huge event along Grand River Avenue. Merchants would move their wares outside on the sidewalk, encouraging customers to buy with discounted prices. The sidewalk sale still occurs, but it pales in comparison to its original size. (UAHC.)

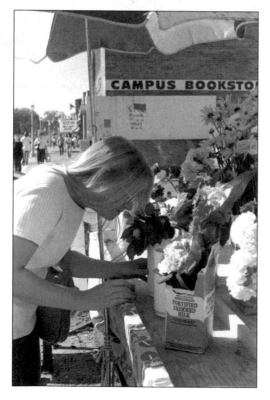

STUDENT-RUN BUSINESSES, 1971. Grand River Avenue across from campus is the perfect place for students to try their hand at entrepreneurship. This was a student-run flower stand.

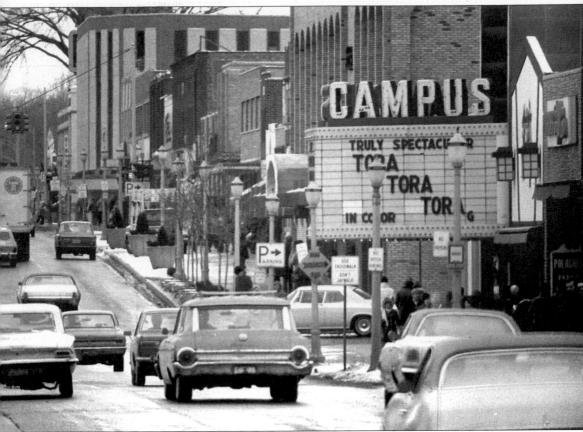

GRAND RIVER AVENUE, 1971. The congestion along Grand River Avenue is evident in this photo, but the malls had drawn away many local stores and customers. Businesses new and old soon began to cater to the only captive audience they had: the students. Unique youth-orientated stores and bars soon dotted downtown. (UAHC.)

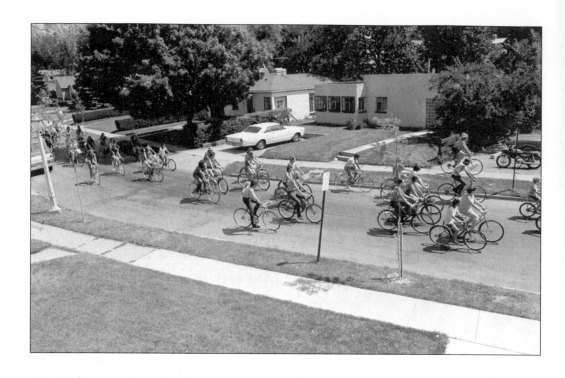

BIKE TOUR, 1971. Automobile congestion, the ecology movement, and the popular tradition of bicycling in East Lansing prompted this bike tour through the downtown and various neighborhoods. (UAHC.)

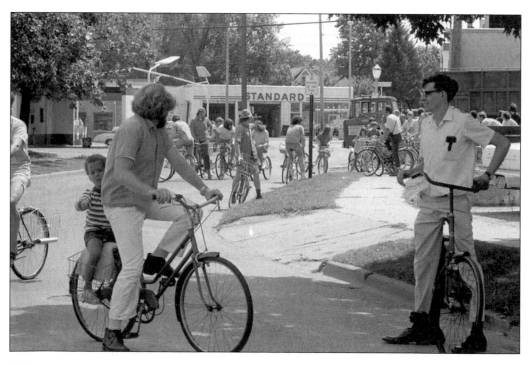

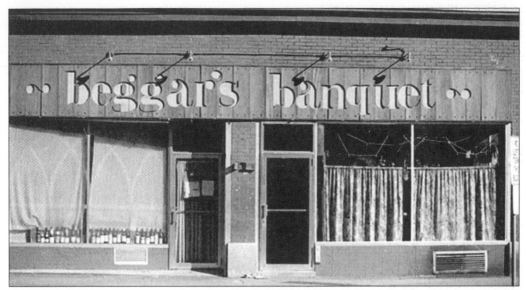

BEGGAR'S BANQUET, 1973. The most dramatic change in East Lansing since the influx of World War II veterans was the 1968 decision to allow the sale of alcohol. This was a very hotly debated topic, but in the end, residents voted 2-1 to change the city charter. The primary motivation was the hope that by allowing alcohol sales, patrons would return to the downtown area for shopping, entertainment, and restaurants. Beggar's Banquet, an upscale restaurant and bar, was the first to open inside the city limits in 1973. (Joey Harrison.)

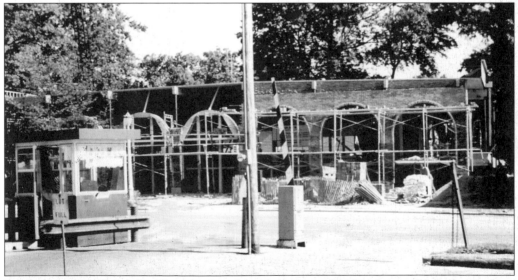

DOOLEY'S, 1973. Soon after Beggar's opened, construction on Dooley's began. Dooley's was a large two-story establishment that catered to students; although they did serve food, it was primarily a bar. Extremely popular (with students), these types of bars that popped up all over town soon had residents and police questioning the choice they had made to sell alcohol in the city. (EL.)

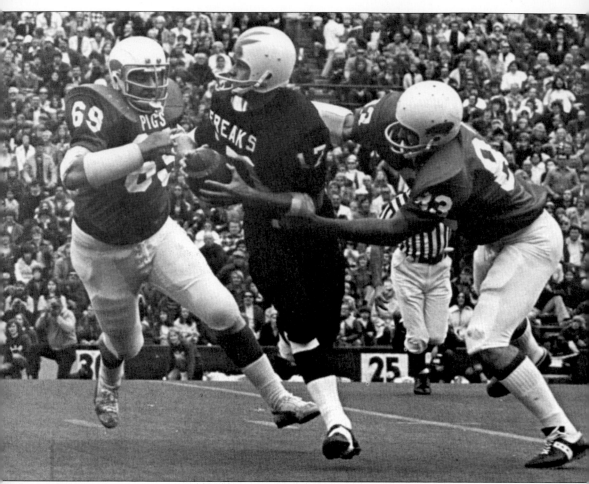

PIGS & FREAKS GAME, 1975. Despite the animosity created by the 1970 riots, East Lansing was able to recover and turn the situation around. The Pigs and Freaks game started in 1970. The policemen, firemen, and federal agents (the Pigs) were pitted against students, locals, and former athletes (the Freaks) in a game to raise money for charity. The Pigs could be identified by an outline of a pig on their helmet and the Freaks by an outline of a large marijuana leaf on theirs. The games, dubbed the Bull Bowl, were a widely popular community event held in Spartan Stadium. (UAHC.)

Four

Eye Toward the Past, Change Toward the Future

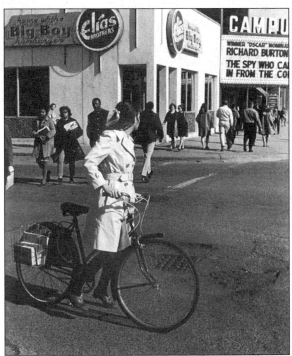

DOWNTOWN EAST LANSING, 1966. A student prepares to return to campus across Grand River Avenue. Although Big Boy and theaters have disappeared in East Lansing, plans are being made for their return. At the turn of the 21st century, East Lansing has come to embrace its historic landmarks while planning for the changes that growth and time brings.

CAUSALITIES, 1974. The pictures of downtown that appear here were taken in 1974. Although many of these establishments were beloved hallmarks of the East Lansing business community, none of them are still in business. (Joey Harrison.)

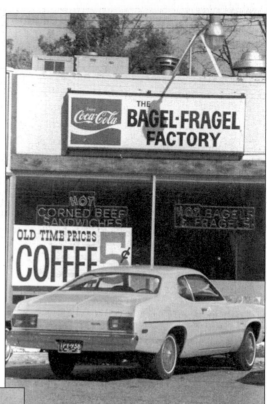

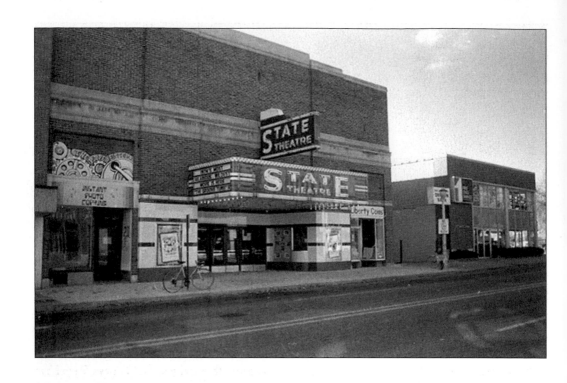

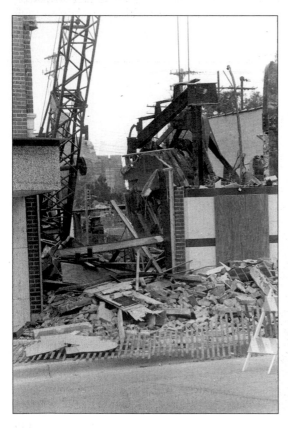

STATE THEATER, 1984. East Lansing's oldest operating theater was torn down in 1984 to install a parking lot. (Dave Thomas.)

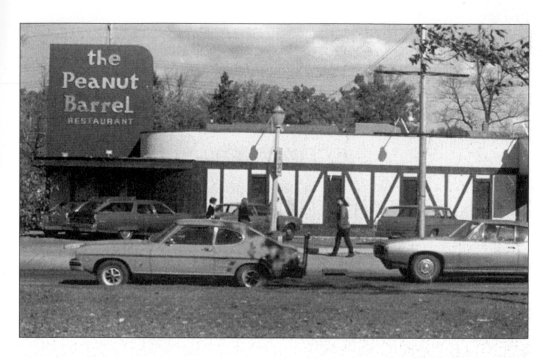

SURVIVORS. A few businesses have survived by reinventing themselves. The Peanut Barrel bar and restaurant, shown here in 1974, reduced its size in the 1980s to become more intimate, while the Student Book Store expanded to encompass almost an entire block, as shown in this 2002 picture.

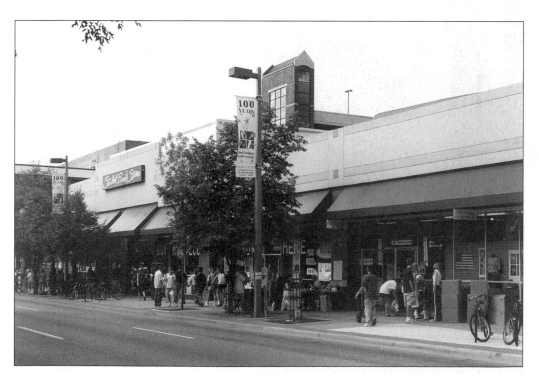

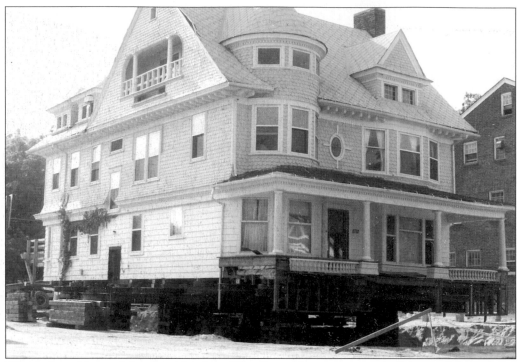

WOODBURY HOUSE MOVE, 1984. The Woodbury House was originally located at 110 W. Grand River and was the home of the Hesperian Society until 1926. The house was moved to 323 Ann Street that year, and stayed there until it was moved again to 415 M.A.C. Avenue in 1984. This photo depicts its last move. (Whitney Miller.)

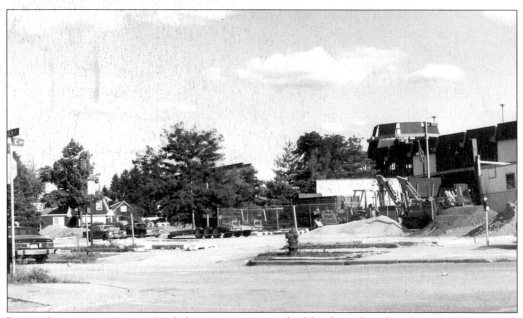

LAND CLEARING, 1984. Work began in 1984 to build a large hotel within the downtown. Building a hotel would capitalize on the many people who visited the city and campus but had to stay elsewhere. This photo shows the initial land clearing. (Whitney Miller.)

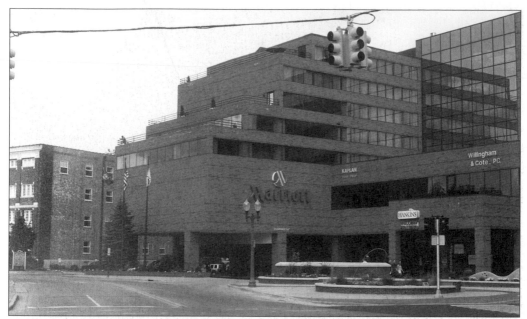

EAST LANSING MARRIOTT HOTEL, 2002. It took several years for the hotel to finally be built, but today it is an entire complex that includes guest rooms, an office building, parking garages, stores, and conference areas. Note the Masonic Temple in the distance. (Whitney Miller.)

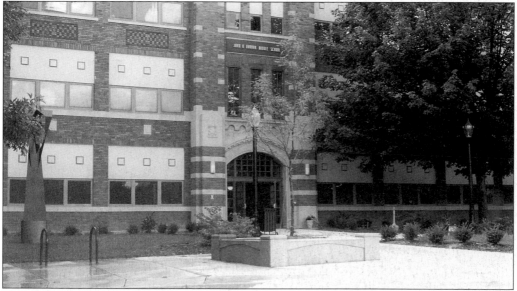

HANNAH COMMUNITY CENTER, 2002. In the late 1980s, East Lansing launched a campaign to focus attention on its historic properties. Six historic residential districts within city limits were recognized, and guidelines were created to preserve these structures. The historic district movement created a public awareness about the uniqueness of East Lansing and prompted an attitude of adaptive reuse and historic preservation instead of demolition. With this in mind, the old East Lansing High School was painstakingly renovated to start a new life as a beautiful community center. It was named after John Hannah, community leader and President of MSU from 1941 to 1969. (Whitney Miller.)

MASONIC TEMPLE, 1984 AND 2001. In addition to historic districts, individual landmark buildings have been identified and restored in East Lansing. The Masonic Temple, built in 1916, was one of the early downtown buildings. It was bought in 1986 and renovated. It is on the National Register of Historic Places, and was recently established as a Michigan Historic Site. (Whitney Miller.)

CITY CENTER, 2002. Many of the downtown buildings that were built in the 1950s and 1960s began to look dated and worn. In 2001, East Lansing launched a campaign to replace some of these buildings with an architectural and functional style that would better blend into the downtown area. The City Center was constructed along the east side of M.A.C. Avenue with a mixture of residential and commercial units. (Whitney Miller.)

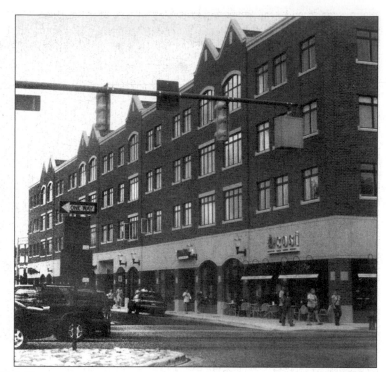

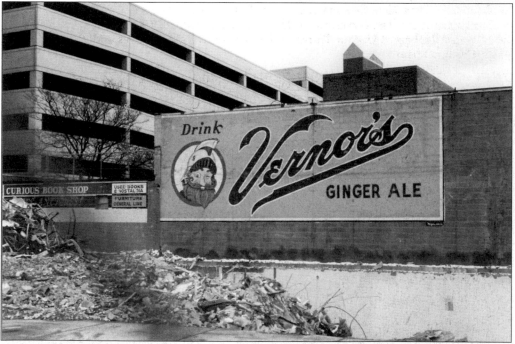

VERNOR'S SIGN SURPRISE, 2001. In preparation for building the City Center, the 1955 Byrnes Building was demolished. This building had abutted directly against the wall of the adjacent Brown Building. Once its previously hidden eastern exterior wall was exposed, this beautifully preserved sign was revealed. The Vernor's gnome is wearing a Spartan helmet as a tribute to the MSU mascot. When City Center was completed, the sign was hidden once more. (Whitney Miller.)

EAST LANSING

A half-century after the Grand River plank road was built in 1850, street cars and interurban railroads linked the state capital to the Michigan Agricultural College. The end of the streetcar line formed a wye (turn-around triangle) at the intersection of Ann, Albert and M. A. C. streets. In 1907 a committee, led by Agricultural College postmaster Charles Collingwood, proposed a charter for "College Park" to the state legislature. On May 8, 1907, following extensive debate, legislators chartered "East Lansing." The city's first paved road, Michigan Avenue, was completed by 1916, and the police and fire departments were established in 1921 and 1924. East Lansing experienced its greatest growth between 1950 and 1960 when its land area tripled and its population increased by 50 percent.